ARTEMISIA

TEXT BY
NATHALIE FERLUT

DRAWINGS BY
TAMIA BAUDOUIN

BEEHIVE BOOKS

Thank you to Christine and David, without whom this book wouldn't exist…
— *Nathalie Ferlut*

Thank you to my big wonderful family, to Nathalie and David for their trust, to my studio friends for the snacks and the worms sessions, to Christine who connected me to Nathalie, to Loïc for his invaluable support during the creation of this book, and to the wonderful people I was lucky enough to meet during my studies in Brussels and on my trip to Japan.
— *Tamia Baudouin*

Nathalie Ferlut can be found at: nathalieferlut.tumblr.com
Tamia Baudouin can be found at: tamiabaudouin.com

Translation: Maëlle Doliveux (with assistance from Andrew Dubrov)
Designer: Luke Wohlgemuth
Published by Beehive Books, Philadelphia | Publisher / Editor: Josh O'Neill
Creative Director: Maëlle Doliveux | Associate Editor: Violet Kitchen
Co-publishers: Iris Loew-Friedrich, Cato Vandrare

The publishers would like to thank the French Embassy in the United States for their generous aid through the Hemingway Grant Program. This work received support from the French Ministry of Foreign Affairs and the Cultural Services of the French Embassy in the United States through their publishing assistance program.

First edition, 2021. Printed in China in an edition of 3500 copies.
ISBN: 978-1-948886-11-6

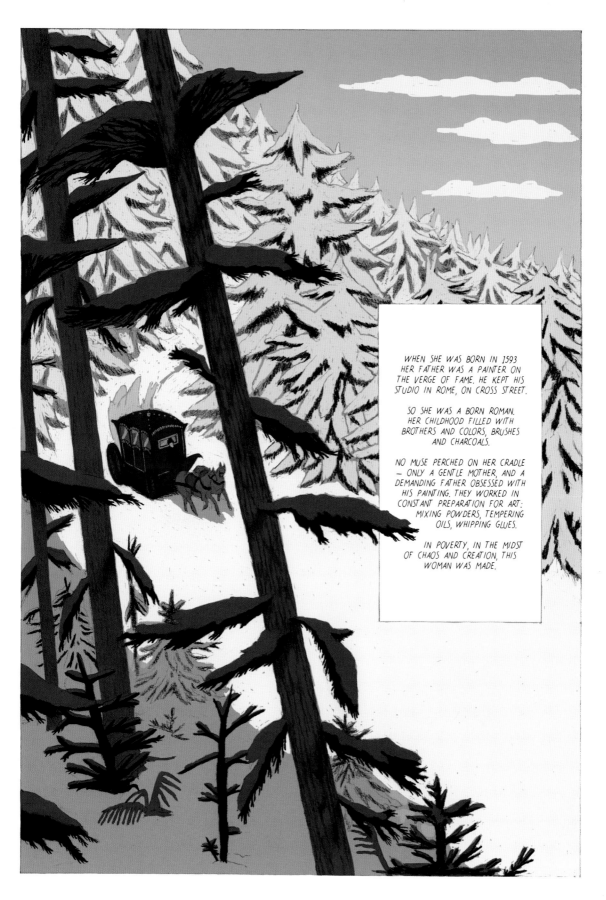

WHEN SHE WAS BORN IN 1593
HER FATHER WAS A PAINTER ON
THE VERGE OF FAME. HE KEPT HIS
STUDIO IN ROME, ON CROSS STREET.

SO SHE WAS A BORN ROMAN.
HER CHILDHOOD FILLED WITH
BROTHERS AND COLORS, BRUSHES
AND CHARCOALS.

NO MUSE PERCHED ON HER CRADLE
— ONLY A GENTLE MOTHER, AND A
DEMANDING FATHER OBSESSED WITH
HIS PAINTING. THEY WORKED IN
CONSTANT PREPARATION FOR ART:
MIXING POWDERS, TEMPERING
OILS, WHIPPING GLUES.

IN POVERTY, IN THE MIDST
OF CHAOS AND CREATION, THIS
WOMAN WAS MADE.

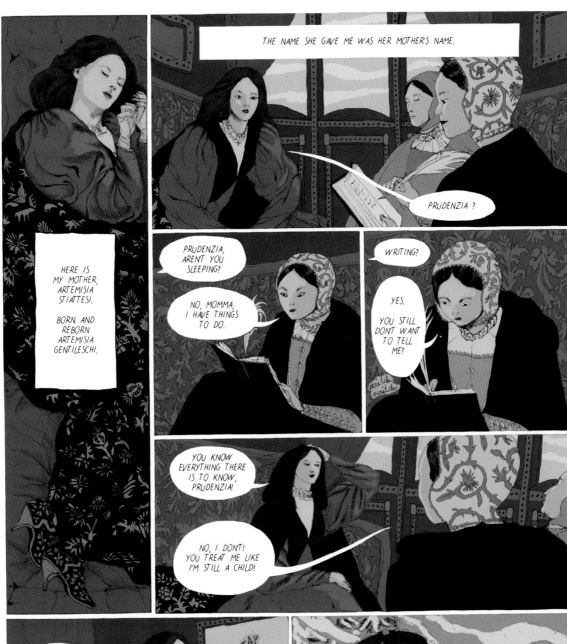

THE NAME SHE GAVE ME WAS HER MOTHER'S NAME.

PRUDENZIA?

HERE IS MY MOTHER, ARTEMISIA STIATTESI.

BORN AND REBORN ARTEMISIA GENTILESCHI.

PRUDENZIA, AREN'T YOU SLEEPING?

NO, MOMMA, I HAVE THINGS TO DO.

WRITING?

YES.

YOU STILL DON'T WANT TO TELL ME?

YOU KNOW EVERYTHING THERE IS TO KNOW, PRUDENZIA!

NO, I DON'T! YOU TREAT ME LIKE I'M STILL A CHILD!

GOOD LORD! I'LL NEVER MAKE IT TO THE INN!

TAP TAP

THIS CURSED CARRIAGE NEEDS TO STOP IMMEDIATELY!

YOU ARE STILL A CHILD IN MANY WAYS.

I'M 18 YEARS OLD. AT MY AGE, SHE WAS ALREADY MARRIED, FAMOUS, AND...

THOSE 18 YEARS OF HERS SHOULD NOT BE ENVIED.

PFFT! YOU DON'T KNOW ANY MORE THAN I, YET ACT LIKE YOU KNOW EVERYTHING!

IS IT THE CONVENT THAT MADE YOU SO MEAN, MISS?

FORGIVE ME, MARTA!

COME NOW, STOP FIDGETING SO I CAN BRUSH YOUR HAIR.

IF YOU'RE IN SUCH A HURRY TO MARRY, YOU'D BETTER TAKE CARE OF YOURSELF AND BECOME A BEAUTIFUL WOMAN!

WITH WHAT MOMMA SAVED FOR MY DOWRY, SHE'LL HAVE NO TROUBLE FINDING ME A HUSBAND. AND I LEARNED ALL A MARRIED GIRL NEEDS TO KNOW AT THE CONVENT!

YOU DID? HEAVENS! THE NUNS MUST HAVE CHANGED SINCE I WAS A GIRL...

AND NOW YOUR MOTHER'S WANDERING OFF!

I HATE TO SEE HER SO WORKED UP. YOU SHOULD STOP ASKING HER SO MANY QUESTIONS!

IT'S NOT AS IF SHE'S GIVING ME ANY ANSWERS. AND IF YOU'D HEARD WHAT THEY SAID ABOUT HER AT THE CONVENT...

DON'T YOU WANT TO GET OUT OF THE CARRIAGE FOR A BIT? IT DOES WORLD OF GOOD!

BRRR! SOUNDS AWFUL!

PLEASE! LET'S LEAVE, MOMMA IT'LL BE DARK SOON!

4

I THINK YOU'RE LYING. I KNOW YOU'VE ALWAYS BEEN A PAINTER.

WHAT A STUBBORN DAUGHTER I HAVE!

ROME, 1606.

GENTILESCHI!

GENTILESCHI!

HAVE YOU HEARD THE NEWS? ROME IS BUZZING WITH IT!

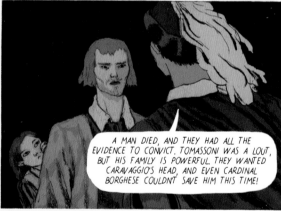

MERISI DISAPPEARED! THE TRIBUNAL SENTENCED HIM TO DEATH, AND HE FLED FROM ROME!

HAH! I'M SURE THE STREET BUMS ARE GRIEVING FOR HIM!

GOOD LORD... CARAVAGGIO, CONDEMNED? HOW CAN THAT BE?

A MAN DIED, AND THEY HAD ALL THE EVIDENCE TO CONVICT. TOMASSONI WAS A LOUT, BUT HIS FAMILY IS POWERFUL. THEY WANTED CARAVAGGIO'S HEAD, AND EVEN CARDINAL BORGHESE COULDNT SAVE HIM THIS TIME!

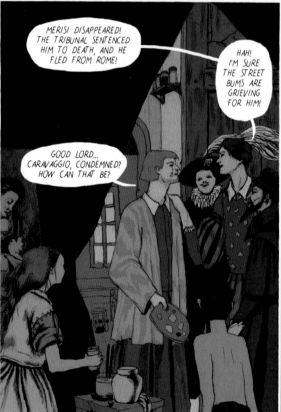

MERISI DA CARAVAGGIO. WHAT A DEVIL OF A MAN. EQUAL PARTS SIN AND GENIUS AND SCOUNDREL.

WHAT A PRETTY LITTLE CANVAS!

AND THIS IS ALSO QUITE PRETTY! ARE YOU MAKING LITTLE GIRLS WORK, ORAZIO?

LET ME GO!

DON'T TOUCH ME!

HA! AND SHE BITES, TOO! HOW OLD IS SHE? LET ME BORROW HER TO POSE FOR ME!

I'M 13! AND I'M THE DAUGHTER OF ORAZIO GENTILESCHI, YOU LITTLE—

ARTEMISIA! ENOUGH!

I WORK FOR MY FATHER. I WOULD NEVER POSE FOR YOU.

I PREPARE HIS COLORS AND PAINT HIS BACKGROUNDS BETTER THAN ANYONE ELSE.

AND I DRAW AND PAINT, TOO! YOU'LL SEE, BEFORE LONG I'LL BE A PAINTER JUST AS GOOD AS YOU ARE!

HA HA HA HA!

BETTER, EVEN! FATHER SAYS THAT—

ARTEMISIA! ENOUGH!

GO TO THE KITCHEN INSTEAD OF MAKING UP STORIES!

SO YOU'RE REALLY TEACHING YOUR DAUGHTER TO PAINT? BUT I THOUGHT YOU HAD SONS...

WELL, IT'S NOT WHAT I WOULD HAVE WANTED. SHE'S JUST BEEN PICKING IT UP HERSELF!

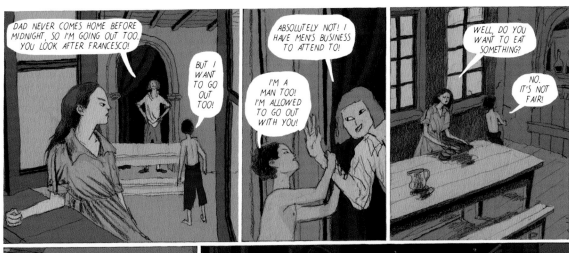

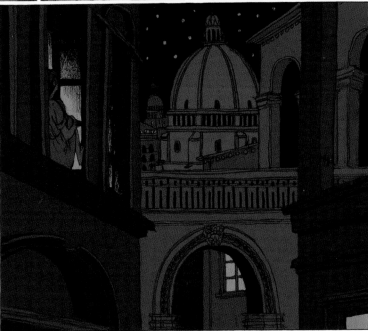

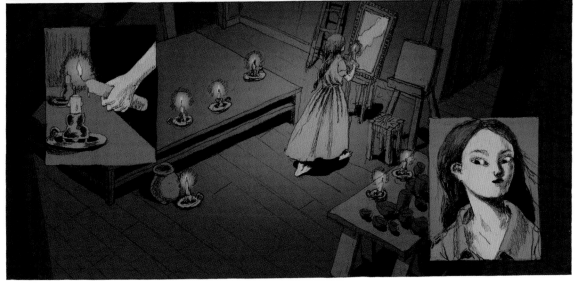

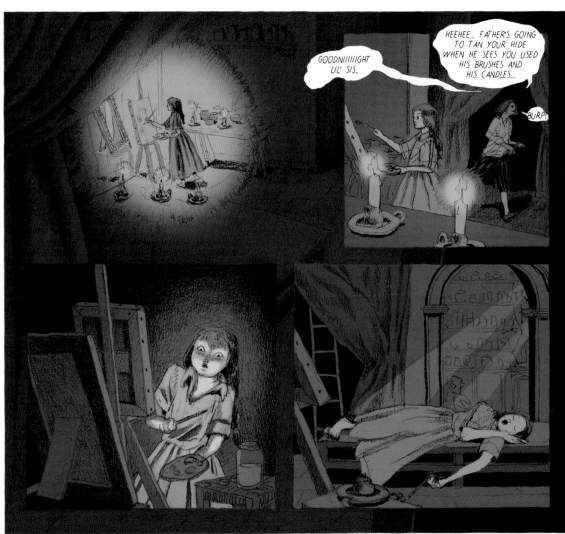

11

ARTEMISIA!! WELL — DON'T YOU RECOGNIZE ME AFTER ALL THESE YEARS?

MARCO...

THAT SCOUNDREL, MARCO! THIS CAN'T BODE WELL... COME, LET'S HEAD UPSTAIRS!

NOT YET! WHO IS HE?

I'VE FOUND A CLEAN SPOT FOR US TO DINE TOGETHER! AND I'LL BE ABLE TO LOOK OVER THAT TREASURE YOU'VE BROUGHT FOR US!

TREASURE?

YOUR DAUGHTER!

SHE IS... TIRED. SHE WON'T BE JOINING US.

GOOD EVENING, UNCLE.

FINE. MAY AS WELL SIT IF YOU'RE ALREADY HERE.

I DID MY BEST, MADAM!

HA HA! YOUR MOTHER WAS JUST AS STUBBORN AT YOUR AGE! AND SHE HAD THE SAME GORGEOUS FACE AND FIGURE!

LET'S HOPE YOU'LL BE BETTER BEHAVED, THOUGH!

ENOUGH!

OH PLEASE! I'M NOT SAYING ANYTHING SHE WON'T HEAR ALL OVER ROME, ANYWAY!

YOU WERE RIGHT, MOTHER — I REALLY DO NEED SOME SLEEP!

ROME CLEARLY KNOWS NOTHING ABOUT MY MOTHER, UNCLE. IT SEEMS NEITHER DO YOU!

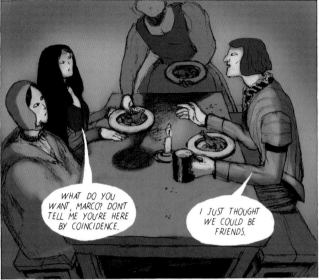

WHAT DO YOU WANT, MARCO? DON'T TELL ME YOU'RE HERE BY COINCIDENCE.

I JUST THOUGHT WE COULD BE FRIENDS.

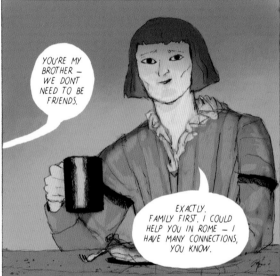

YOU'RE MY BROTHER — WE DON'T NEED TO BE FRIENDS.

EXACTLY. FAMILY FIRST. I COULD HELP YOU IN ROME — I HAVE MANY CONNECTIONS, YOU KNOW.

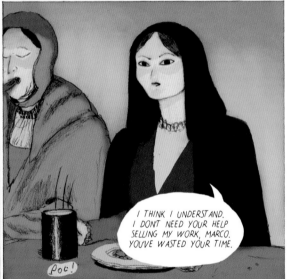

POC!

I THINK I UNDERSTAND. I DON'T NEED YOUR HELP SELLING MY WORK, MARCO. YOU'VE WASTED YOUR TIME.

I SWEAR, I HAVE BUYERS LINED UP FOR YOU.

NO. I LEARNED TO GET BY ON MY OWN A LONG TIME AGO.

THANK YOU FOR DINNER.

YOU'RE WELCOME, LIL' SIS. I TOLD THE INNKEEPER TO PUT IT ON YOUR BILL...

WE'LL TALK IT OVER AGAIN IN THE MORNING, RIGHT?

NO. WE'RE LEAVING VERY EARLY, AND—

I'LL ESCORT YOU TO ROME! THE ROADS AREN'T SAFE, YOU KNOW!

SLEEP ON IT, ARTEMISIA. THE ONLY THING YOU'D HAVE TO DO IS PAINT.

ARGH! I SHOULD HAVE HIM WHIPPED!

OR THROWN DOWN A WELL!

THAT WOULDN'T BE GREAT FOR BUSINESS, MADAM.

TOMORROW WE'LL LEAVE AS EARLY AS POSSIBLE!

MAYBE WE CAN LOSE HIM. OR MAYBE HE'LL GIVE UP.

OF COURSE MADAM, AND MAYBE FOXES WILL STOP CHASING HENS.

ROME, 1611.

LOOK, TASSI!
LOOK AT HER TALENT!

WELL YOU CERTAINLY
WERE'NT LYING. YOUR DAUGHTER
HAS A REAL TOUCH.

BUT MY POOR ORAZIO, THERE'S NO FUTURE
AS A PAINTER FOR A GIRL. THEY'LL NEVER LET HER
INTO THE ACADEMY. THE LAW FORBIDS HER FROM
EVEN BUYING HER OWN PIGMENTS! AT BEST
SHE'D ONLY BE ABLE TO PAINT STILL LIVES,
AND MOTHERS AND BABIES...

I KNOW.
WHAT A WASTE!

IT'S THE WAY THE WORLD
WORKS! THERE MUST BE AN
ORDER TO IT. MEN, WOMEN,
THE POOR, THE RICH...

...EVERYONE HAS THEIR PLACE.
IT'S THE ONLY WAY TO AVOID DISASTER!

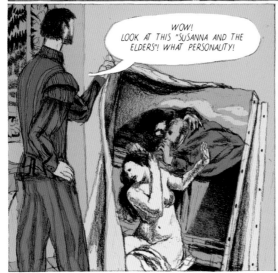

WOW!
LOOK AT THIS "SUSANNA AND THE
ELDERS"! WHAT PERSONALITY!

PUT THAT CANVAS DOWN AND LET'S
GO BACK TO WORK ON THE CHAPEL.
IF ARTEMISIA RETURNS AND CATCHES
US LOOKING AT HER PAINTINGS
WHILE SHE'S GONE...

SO, WHERE IS YOUR DAUGHTER RIGHT NOW?

AT CHURCH SERVICE, LIKE EVERY MORNING, WITH ONE OF HER BROTHERS AND OUR NEIGHBOR TUZIA.

AH! A GOOD GIRL, WITH A CHAPERONE AND ALL!

I'M NOT SURE HOW "GOOD" SHE'S BEING... MEN KEEP APPROACHING HER WHEN SHE GOES OUT, AND SHE DOESN'T KNOW HOW TO BE MODEST.

WELL... HER FIGURES AREN'T BAD, BUT HER BACK- GROUNDS COULD BENEFIT FROM MORE STRUCTURE. IF SHE WERE A BOY, I COULD GIVE HER SOME ADVICE... AND SOME LESSONS...

SO? WHAT'S STOPPING YOU?

IT WOULD FEEL LIKE TEACHING A MONKEY! AND I WORRY ABOUT WHAT PEOPLE WOULD SAY...

I COULD PAY YOU, IF YOU LIKE! PLEASE THINK IT OVER, TASSI, OLD FRIEND!

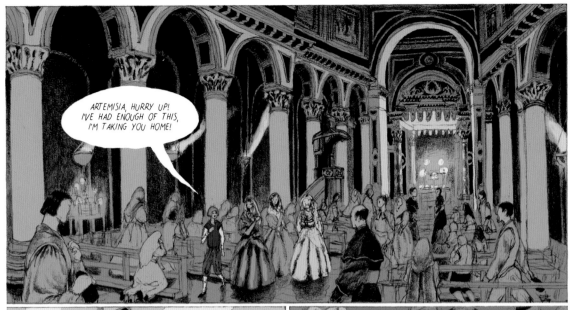

YOU KNOW WHAT? I DON'T EVEN CARE, I'VE ALREADY SEEN YOUR SISTER'S ASS!

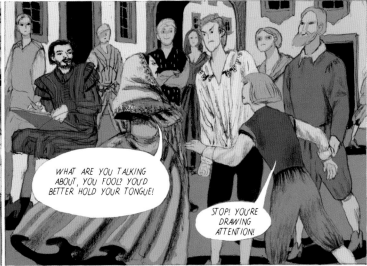

WHAT ARE YOU TALKING ABOUT, YOU FOOL? YOU'D BETTER HOLD YOUR TONGUE!

STOP! YOU'RE DRAWING ATTENTION!

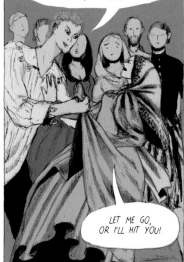

YOU WERE SO BOSSY GIVING ME ORDERS WHEN I WORKED FOR YOUR FATHER, HUH? NOT SO COCKY WHEN I CAN SAY WHAT I LIKE, ARE YOU?

LET ME GO, OR I'LL HIT YOU!

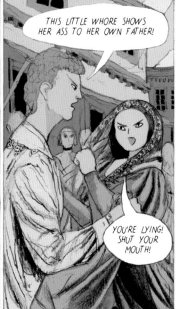

THIS LITTLE WHORE SHOWS HER ASS TO HER OWN FATHER!

YOU'RE LYING! SHUT YOUR MOUTH!

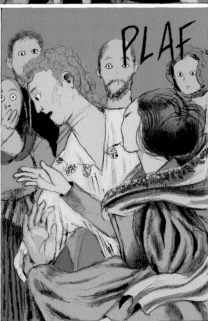

PLAF

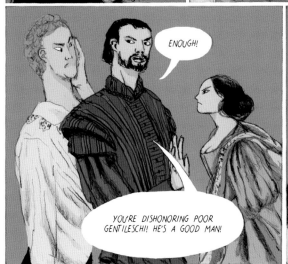

ENOUGH!

YOU'RE DISHONORING POOR GENTILESCHI! HE'S A GOOD MAN!

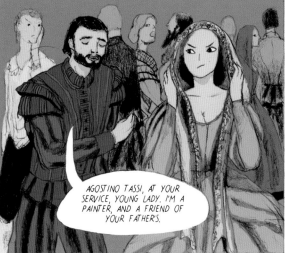

AGOSTINO TASSI, AT YOUR SERVICE, YOUNG LADY. I'M A PAINTER, AND A FRIEND OF YOUR FATHER'S.

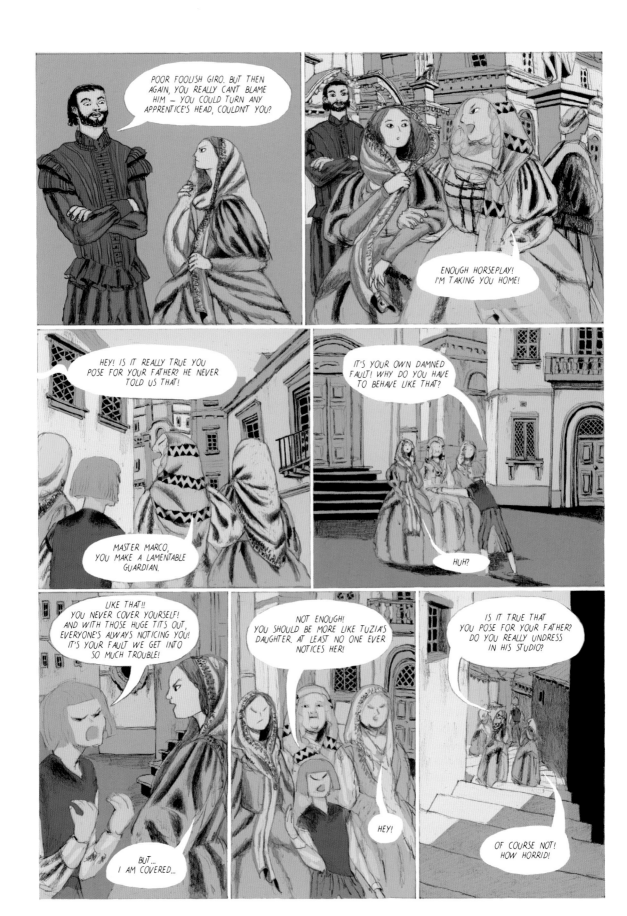

ARTEMISIA, I SAW YOU STUDYING THE LIST OVER THERE ON THE TABLE EARLIER. YOU COULDN'T READ IT, COULD YOU?

OF COURSE I COULD. IT JUST WASN'T ALL THAT INTERESTING.

HMPH. I SUPPOSE YOU'VE BEEN DEVELOPING YOUR READING SKILLS ON YOUR OWN? I TAUGHT YOU ALL THE LETTERS LONG AGO, BUT THE REST IS UP TO YOU. I DON'T HAVE TIME TO TEACH YOU!

YEAH, YEAH. DON'T WORRY SO MUCH!

YOU MUST DO SO, ARTEMISIA. ON YOUR OWN. BETWEEN THE PAINTING COMMISSIONS AND THE PALACE FRESCO, I HAVE SO MUCH WORK, I...

I'M 18. I CAN READ WELL ENOUGH FOR WHAT I NEED TO KNOW.

IF YOUR MOTHER WAS STILL HERE, SHE'D TEACH YOU. AND YOU WOULDN'T BE SUCH A MULE! YOU'D BE MORE GRACEFUL, TOO, LIKE SHE WAS! STOP FIDGETING!

FINE. I'VE HAD ENOUGH FOR TODAY. YOU'LL JUST HAVE TO MAKE MARCO POSE FOR YOU IF YOU LIKE.

YOUR OLD APPRENTICE GIRO IS TELLING EVERYONE THAT HE SAW ME POSING FOR YOU. YOU SHOULD TELL HIM TO KEEP HIS MOUTH SHUT.

PEOPLE ARE GOING TO BE TALKING ABOUT ME AGAIN.

HMM... I'M SURE YOU'LL HAVE A GOOD RETORT READY FOR THEM!

IF PEOPLE ARE PESTERING YOU, TAKE YOUR BROTHER WITH YOU. YOU KNOW I DON'T HAVE TIME FOR THIS SORT OF THING.

YEAH, YEAH.

scritt scritt

I SAW YOUR NEW PAINTING.

scritt scritt

IT'S COMING ALONG WELL!

THERE'S SOME VERY NICE DETAILS. YOUR DRAPERY IS... QUITE GOOD.

NOT TOO MUCH RED THIS TIME AROUND?

NO. IT'S JUST YOUR SCENERY THAT MAKES ME WONDER...

COME ON! THERE'S PRACTICALLY NO SCENERY! JUST A BIT OF A COLUMN!

EXACTLY. YOU HAVE TO LEARN HOW TO PAINT BACKGROUNDS. IT'S VITAL, AND THIS AFTERNOON I WAS THINKING...

HMPH! IT'LL BE FINE! I'LL GET BETTER ON MY OWN. YOU'VE SAID MY SET PIECES ARE ALREADY PRETTY GOOD!

ON THE CONTRARY — IT'S EXTREMELY IMPORTANT! YOU CANT AFFORD TO NEGLECT YOUR BACKGROUNDS! AND YOU'LL LEARN TWICE AS FAST WITH A TEACHER AS YOU WOULD BY YOURSELF.

WHAT DO YOU MEAN — AN ART TUTOR? BUT YOU'RE ALREADY TEACHING ME HOW TO PAINT...

OF COURSE I AM! AND YOU ARE A GREAT PUPIL. BUT BACKGROUNDS ARENT MY STRONG SUIT.

THERE'S A PAINTER I WORK WITH AT THE PALACE NAMED TASSI. HE'S VERY GOOD — AND HIS BACK-GROUNDS ARE SUPERB. HE COULD REALLY TEACH YOU A THING OR TWO!

TASSI...? I THINK I MAY HAVE MET HIM YESTERDAY...

scritt scritt...

I'VE ASKED HIM, AND HE'S ALREADY AGREED TO IT.

HE'S A CLOSE FRIEND, SO IT WONT COST TOO MUCH!

MAYBE IT'S NOT SUCH A GOOD IDEA. HE WAS WITH THAT IDIOT GIRO, AND HE...

HAH! WITH MY DRAPERY, AND HIS BACKGROUNDS, YOUR PAINTINGS WILL REALLY SING!

YOU'RE GOING TO MAKE A FORTUNE!

IT DOESNT MATTER IF YOU'RE A GIRL, WE'LL SHOW THEM!

ding

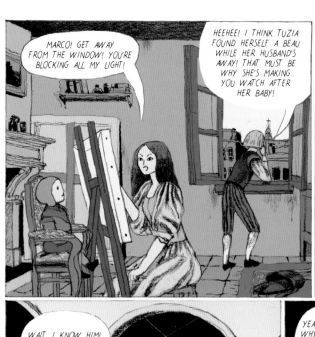

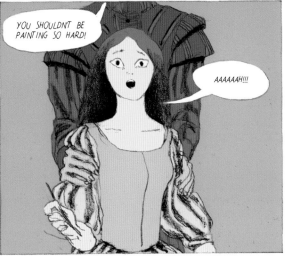

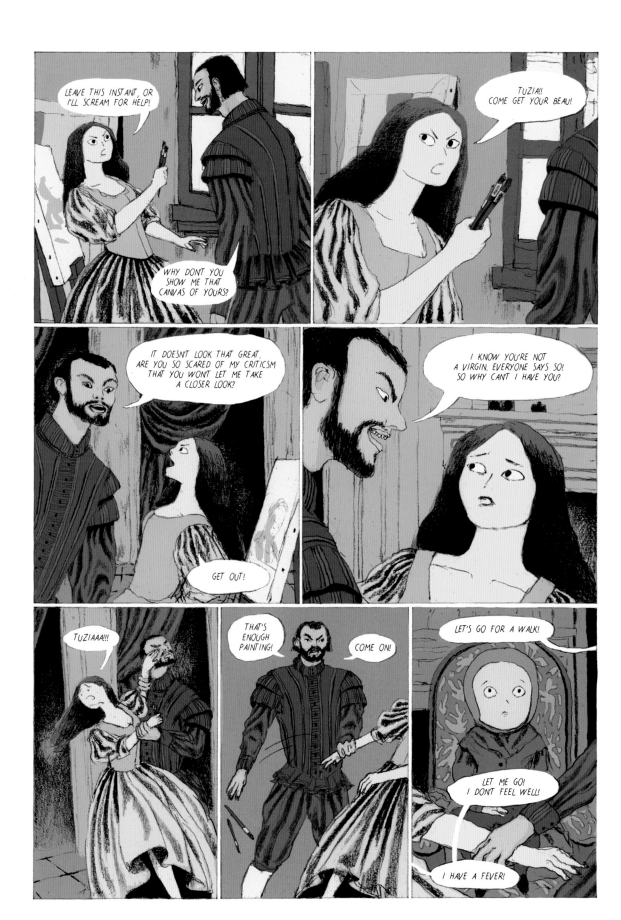

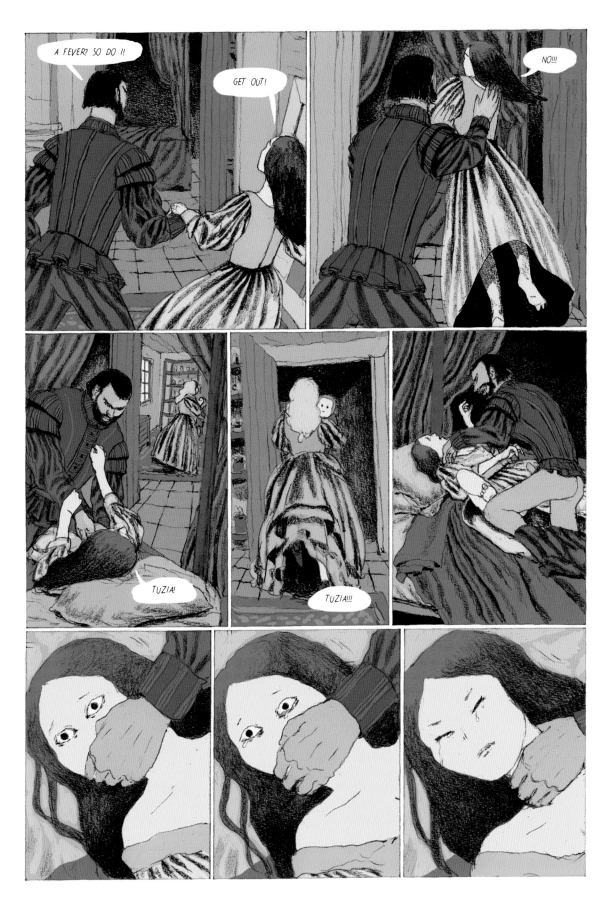

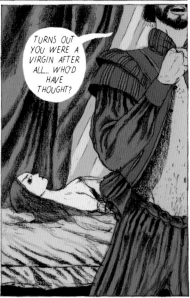

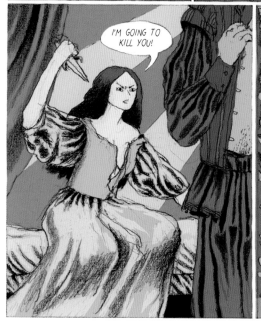

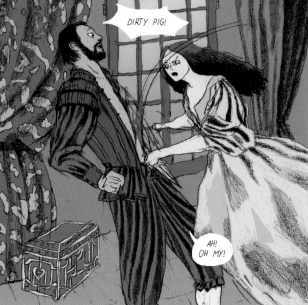

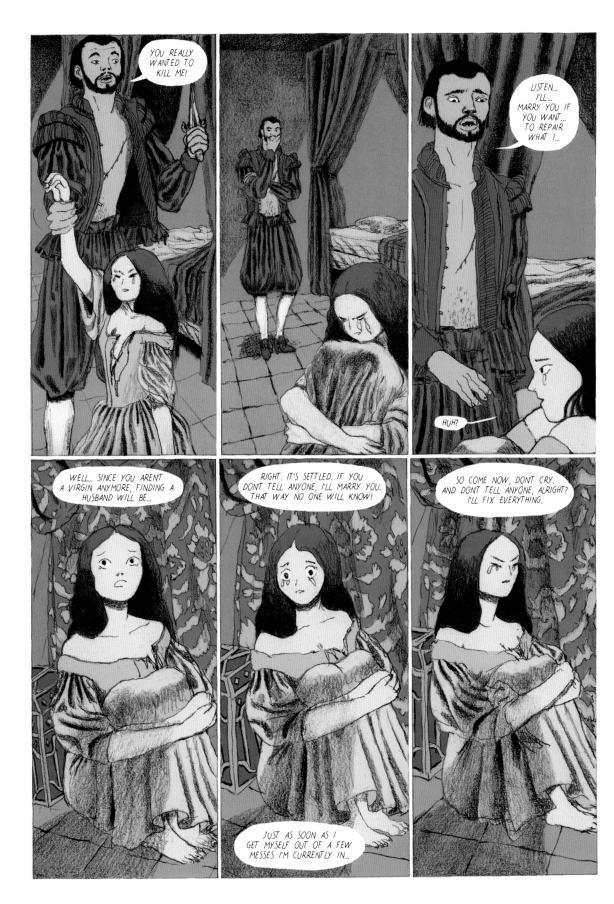

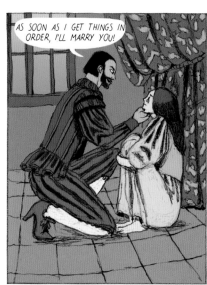

AS SOON AS I GET THINGS IN ORDER, I'LL MARRY YOU!

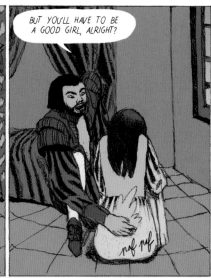

BUT YOU'LL HAVE TO BE A GOOD GIRL, ALRIGHT?

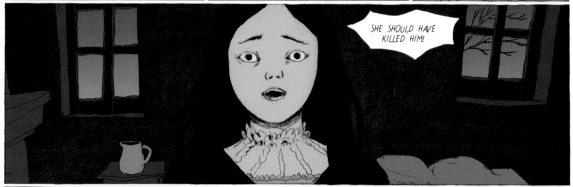

SHE SHOULD HAVE KILLED HIM!

THIS IS AWFUL, MARTA! WHY ARE YOU TELLING ME ALL THIS?!

WELL, YOU SAID YOU WANTED TO KNOW EVERYTHING...

NOW GO PUT YOUR TRUNK IN THE CARRIAGE. YOUR MOTHER WANTS TO LEAVE BEFORE DAYBREAK..

POOR MOTHER...

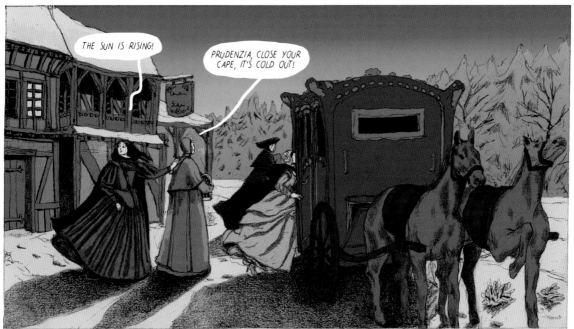

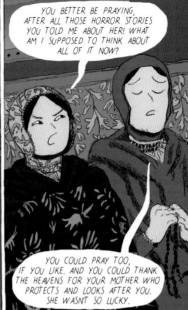

YOU BETTER BE PRAYING, AFTER ALL THOSE HORROR STORIES YOU TOLD ME ABOUT HER! WHAT AM I SUPPOSED TO THINK ABOUT ALL OF IT NOW?

YOU COULD PRAY TOO, IF YOU LIKE. AND YOU COULD THANK THE HEAVENS FOR YOUR MOTHER WHO PROTECTS AND LOOKS AFTER YOU. SHE WASN'T SO LUCKY.

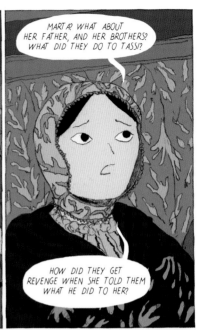

MARTA? WHAT ABOUT HER FATHER, AND HER BROTHERS? WHAT DID THEY DO TO TASSI?

HOW DID THEY GET REVENGE WHEN SHE TOLD THEM WHAT HE DID TO HER?

WHEN SHE TOLD THEM? OH, MY SWEET LITTLE BIRD, WOULD YOU BELIEVE SHE NEVER TOLD ANYONE?

WHAT DO YOU MEAN SHE NEVER TOLD ANYONE? MARTA, STOP MAKING THINGS UP, WHY WOULDN'T SHE...?

WHY WOULDN'T SHE COME FORWARD? WELL, THAT IS A GOOD QUESTION!

HA HA!

WHY DOESN'T ANYONE EVER COME FORWARD IN THOSE MOMENTS, SWEET PRUDENZIA?

HA! THAT BITCH REALLY HAD IT COMING!

WHAT A SLUT!

32

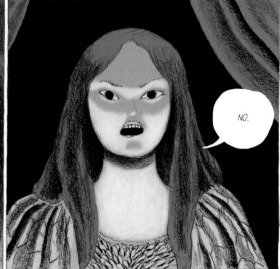

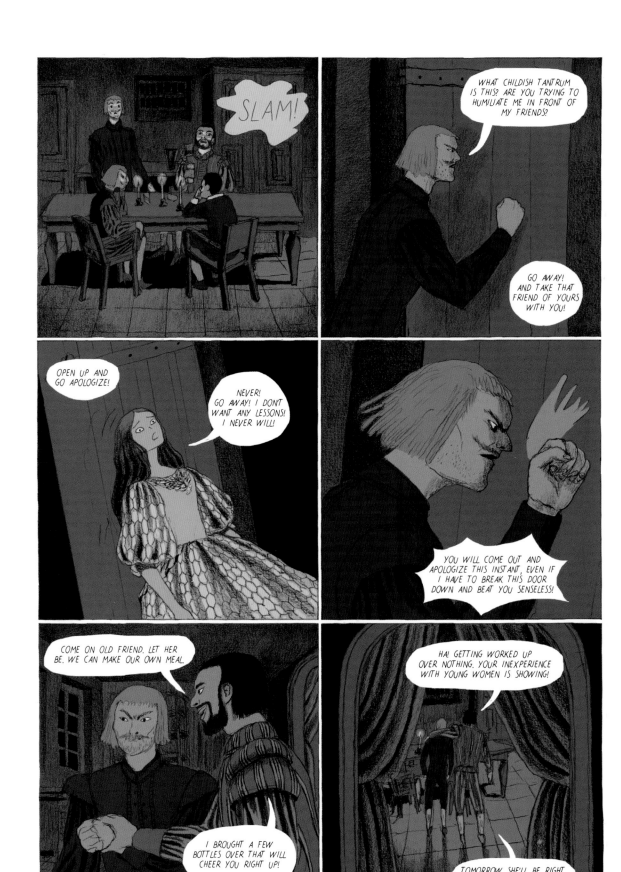

OF COURSE SHE DIDN'T RETURN TO HER SWEET SELF THE NEXT DAY. TASSI, ON THE OTHER HAND, DID RETURN...

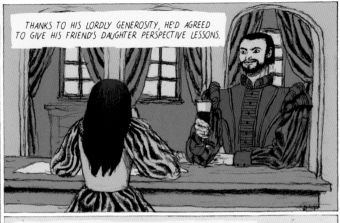

THANKS TO HIS LORDLY GENEROSITY, HE'D AGREED TO GIVE HIS FRIEND'S DAUGHTER PERSPECTIVE LESSONS.

HE WATCHED HER LIKE A HAWK, DELIGHTING WHEN HIS PREY TREMBLED. SHE WANTED TO SCREAM, BUT COULD ONLY FIND A FRIGHTENED SILENCE TO PLACE BETWEEN THEM.

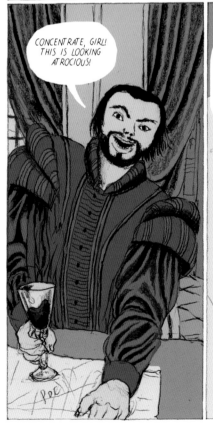

CONCENTRATE, GIRL! THIS IS LOOKING ATROCIOUS!

WHEN WOMEN DRAW YOU ALWAYS MAKE THINGS SO SOFT AND ROUND. YOU NEVER KNOW WHERE TO DRAW A STRAIGHT LINE.

YOU THINK TOO MUCH!

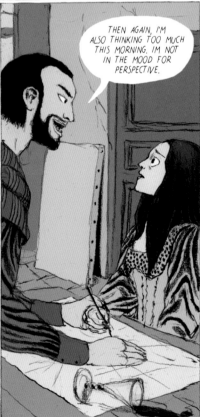

THEN AGAIN, I'M ALSO THINKING TOO MUCH THIS MORNING. I'M NOT IN THE MOOD FOR PERSPECTIVE.

35

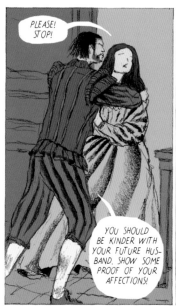

PLEASE! STOP!

YOU SHOULD BE KINDER WITH YOUR FUTURE HUS-BAND. SHOW SOME PROOF OF YOUR AFFECTIONS!

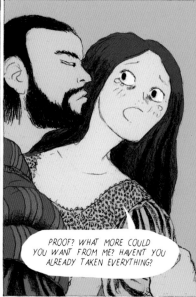

PROOF? WHAT MORE COULD YOU WANT FROM ME? HAVENT YOU ALREADY TAKEN EVERYTHING?

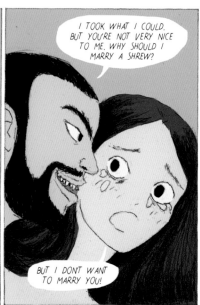

I TOOK WHAT I COULD. BUT YOU'RE NOT VERY NICE TO ME. WHY SHOULD I MARRY A SHREW?

BUT I DONT WANT TO MARRY YOU!

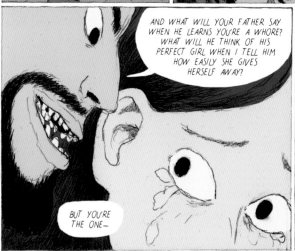

AND WHAT WILL YOUR FATHER SAY WHEN HE LEARNS YOU'RE A WHORE? WHAT WILL HE THINK OF HIS PERFECT GIRL WHEN I TELL HIM HOW EASILY SHE GIVES HERSELF AWAY?

BUT YOU'RE THE ONE—

"YOU'RE THE ONE!" WHAT A PRETTY TUNE! I'M THE ONE HE HIRED TO TEACH HIS DAUGHTER ART... AND TO KEEP HER CHASTE!

WHAT?!

THAT'S RIGHT! YOUR SWEET OLD MAN IS GETTING SUSPICIOUS OF YOUR MODESTY. HE OVERHEARD HIS OLD APPRENTICE BLABBERING...

AND HE SEES ALL THOSE MEN LEERING AT YOU WHEN YOU GO TO MASS. HOW CAN HE BE SO SURE YOU'RE NOT OFF SOMEWHERE BEING A HUSSY WHILE HE'S AWAY?

SO, WHAT DO I TELL HIM NOW? "DEAR ORAZIO, YOUR PRECIOUS PRODIGY HAS NO HEAD FOR PERSPECTIVE..."

"AND AS TO YOUR OTHER CONCERN... IF A MIDWIFE TOOK A LOOK BETWEEN HER LEGS, SHE CERTAINLY WOULDNT FIND AN INNOCENT GIRL!"

MY SWEET PRUDENZIA, YOU ARE STILL WONDERING WHY SHE DIDNT COME FORWARD, ARENT YOU?

POC!

AND HOW SHE COULD BELIEVE IN THAT SCOUNDREL TASSI—

—INSTEAD OF PUTTING HER FAITH IN THE MAN WHO RAISED HER?

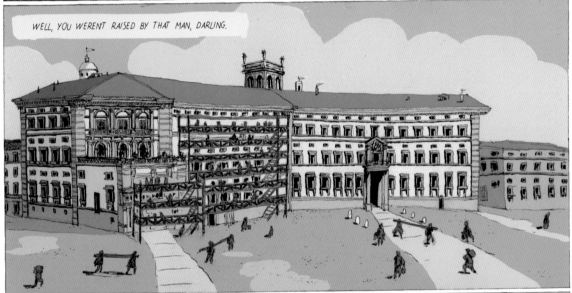

WELL, YOU WERENT RAISED BY THAT MAN, DARLING.

STRICT, HARSH ORAZIO.

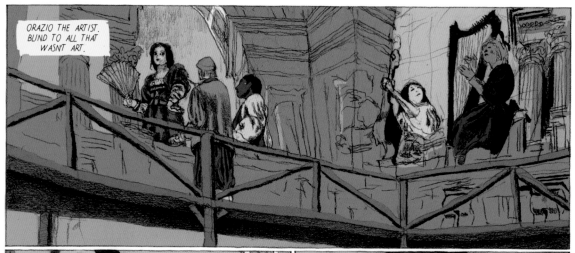

ORAZIO THE ARTIST. BLIND TO ALL THAT WASN'T ART.

IN A SENSE, HE DID KNOW HIS DAUGHTER WELL. AFTER ALL, HE'D PAINTED HER FEATURES A THOUSAND TIMES.

BUT DID HE EVER LISTEN TO HER?

IS THIS MEANT TO BE YOUR DAUGHTER? SHE'S A BIT PLUMP, DON'T YOU THINK?

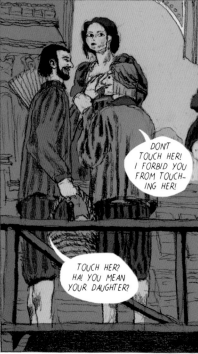

NEVER TOUCH MY PAINTINGS, YOU HEAR ME? I COULD NEVER BEAR IT!

DON'T TOUCH HER! I FORBID YOU FROM TOUCH-ING HER!

TOUCH HER? HA! YOU MEAN YOUR DAUGHTER?

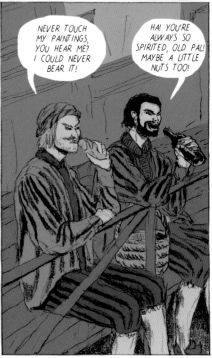

HA! YOU'RE ALWAYS SO SPIRITED, OLD PAL! MAYBE A LITTLE NUTS TOO!

HMPH! I HATE IT WHEN YOU'RE LIKE THIS. ARE YOU NOT GOING TO SPEAK TO ME TONIGHT?

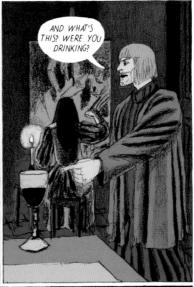

AND WHAT'S THIS? WERE YOU DRINKING?

NO. I THOUGHT YOU KNEW ME BETTER.

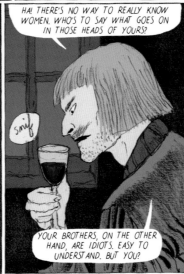

HA! THERE'S NO WAY TO REALLY KNOW WOMEN. WHO'S TO SAY WHAT GOES ON IN THOSE HEADS OF YOURS?

Sniff

YOUR BROTHERS, ON THE OTHER HAND, ARE IDIOTS. EASY TO UNDERSTAND. BUT YOU?

WHAT'S THIS NEW WAY YOU HAVE OF SPEAKING OF YOUR FAMILY, FATHER? YOU DON'T SOUND LIKE YOURSELF. IT'S AS IF I'M LISTENING TO YOUR GREAT FRIEND TASSI!

HMPH! TASSI AND I DON'T DISCUSS THAT STUFF.

OH REALLY? SO WHAT DO YOU AND THAT LOWLIFE DISCUSS? ME, PERHAPS? DID YOU HIRE HIM TO KEEP AN EYE ON ME, AND TO BRING YOU BACK ANY GOSSIP HE HEARS?

YOU'RE BORING ME. ENOUGH.

IS THAT WHAT YOU DID TO ME?

YOU HAVENT EVEN ASKED HOW WORK IS GOING AT THE PALAZZO.

IT'S LIKE YOU DONT EVEN CARE ANYMORE!

FINE. HOW IS WORK GOING AT THE PALA—

MARVELOUS! OH IT'S TRULY BEAUTIFUL! ESPECIALLY MY OWN WORK — I WISH YOU COULD SEE IT!

YOU **WILL** SEE IT! I'LL TAKE YOU! TOMORROW IF YOU LIKE!

YOU'LL SEE THE FRESCOES! AND YOU'LL TELL ME WHAT YOU THINK! TOMORROW!

HA HA! YOU SEE? PAINTING WILL ALWAYS BE SACRED BETWEEN US, WONT IT?

IT'S THE ONLY THING EITHER OF US CAN THINK ABOUT!

"SACRED"! HA! YEAH, RIGHT!

IN HIS OWN WAY, I THINK HE MEANT WELL.

YOU THINK HE KNEW, BUT PRETENDED THERE WAS NOTHING TO KNOW?

WHO KNOWS. THE DEAF MAN WHO DOESN'T WANT TO LISTEN IS THE ONE WHO HEARS THE LEAST. AND IN HIS CASE HE WAS BOTH BLIND AND DEAF TO ALL BUT HIS PAINTING...

WHAT ARE YOU SAYING? IF HE KNEW... NO FATHER COULD ACCEPT THAT FATE FOR HIS DAUGHTER!

HMPH! I OCCASIONALLY FORGET HOW YOUNG YOU ARE! YOU KNOW, I'M ONLY TELLING YOU WHAT YOUR MOTHER SAID AT THE TRIAL!

ALL THOSE MONTHS AFTER IT HAPPENED... THAT'S WHAT I DON'T UNDERSTAND. HOW COULD SHE...

THAT PART IS ALWAYS THE MOST DIFFICULT TO EXPLAIN.

NO ONE REALLY UNDERSTANDS. FOR ALMOST A YEAR, TASSI DID AS HE PLEASED, WITHOUT ANYONE KNOWING WHAT WENT ON IN THAT HOUSE... IT WAS A SECRET BETWEEN THEM.

I DON'T KNOW MUCH MORE THAN THAT. I CAN'T EVEN IMAGINE IT. 18-YEAR-OLD ARTEMISIA IS NOT THE WOMAN I KNOW NOW.

BUT I'M SURE SHE WAS JUST AS TOUGH AND SPIRITED...

... AND STRONG, NO DOUBT!

NOT BAD, GIRL! YOU LEARN QUICKLY WHEN YOU PUT A LITTLE HEART INTO IT...

IF YOU WERE A BOY, I COULD TAKE YOU DRAWING OUT-DOORS — SOME OF ROME'S VISTAS WOULD OFFER A REAL CHALLENGE IN PERSPECTIVE!

SO, WHY NOT, TASSI? WHY DON'T YOU BRING ME OUTSIDE?

WELL... YOUR FATHER DOESN'T WANT YOU GOING OUT, AND...

SINCE WHEN DO YOU DO WHAT MY FATHER WANTS?

HE ALSO DOESN'T WANT ANYONE SLEEPING WITH ME, AND THAT HASN'T SEEMED TO KEEP YOU UP AT NIGHT IN ALL THESE MONTHS YOU ABUSED HIS TRUST. AND ME!

SO. IT'S DECIDED. WE'LL GO DRAW OUTDOORS, AND WE'LL TAKE THAT NITWIT TUZIA AND HER KIDS WITH US SO MY FATHER IS REASSURED.

WON'T SHE BE BORED SENSELESS?

HA! HOPEFULLY... THAT MAY DO HER SOME GOOD.

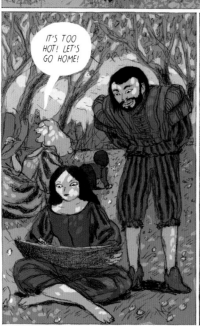

IT'S TOO HOT! LET'S GO HOME!

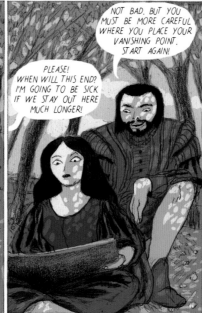

NOT BAD. BUT YOU MUST BE MORE CAREFUL WHERE YOU PLACE YOUR VANISHING POINT. START AGAIN!

PLEASE! WHEN WILL THIS END? I'M GOING TO BE SICK IF WE STAY OUT HERE MUCH LONGER!

WHY NOT LOOK AFTER YOUR SON, THAT SHOULD MAKE THE TIME GO BY. I BET HE'S OFF EATING SOME FILTH AGAIN.

HOW DARE YOU SPEAK TO ME THAT WAY! WHO DO YOU THINK YOU ARE? I'LL TELL YOUR FATHER!

GOOD IDEA. TELL HIM THE WHOLE STORY SO HE KNOWS WHO HE'S DEALING WITH!

YOU GET SO HAUGHTY WHEN YOU TALK TO HER! NOW THERE'S A SIDE OF YOU I LIKE!

I'M CONCENTRATING. STOP BOTHERING ME, TASSI...

YOU THREE WILL HAVE TO GO HOME ON YOUR OWN. LEAVE NOW, AND NO FLIRTING ON THE WAY BACK, ALRIGHT?

WELL, THAT MUST STING. THAT RASCAL TASSI SURE LIKES THEM YOUNG. SHE'S BARELY EVEN HATCHED!

YOU'RE ALREADY PAST YOUR PRIME AT 18, MY DEAR!

WHY SHOULD THAT STING?

IF HE'S FOUND HIMSELF A NEW VICTIM, I'LL BE FREE OF THAT PIG.

SURE, BUT THEN HE WON'T MARRY YOU! HA! IF HE'S THE ONE WHO KNOCKED UP THAT LITTLE ONE...

SHE'S HIS APPRENTICE'S WIFE.

I'M SURE SHE IS.

ONE OF THESE DAYS, YOUR FATHER WILL FIND OUT THE TRUTH, AND IF YOU'RE NOT MARRIED BY THEN, HE'LL THROW YOU OUT OR STICK YOU IN A CONVENT! NO ONE WILL WANT YOU. YOU'RE RUINED, ARTEMISIA.

MY FATHER PAYS YOU TO WATCH OVER ME WITH THAT MOTHERLY HEART OF YOURS, BUT I'M SURE TASSI PAID YOU MORE TO LET HIM DO WHAT HE WANTS TO ME.

YOU'RE JUST A GREEDY PIMP AND AN OLD WHORE, AND YOU CAN KEEP YOUR ADVICE TO YOURSELF.

YOU THINK YOU'RE BETTER THAN US? THAT YOU'RE SOME KIND OF ARTIST?

YOU'RE JUST A WOMAN LIKE THE REST OF US! AND YOU'LL BE SELLING YOUR ASS ON THE STREET TO SURVIVE IN NO TIME!

WELL? YOU SAID YOU'D BE HONEST...

IT'S HARD TO SAY UNTIL IT'S COMPLETELY FINISHED...

COME NOW! WHERE HAS YOUR SHARP EYE GONE? LOOK CAREFULLY AT THAT RAILING BELOW THE VIOLIN...

YES, YOU'RE RIGHT. THE PERSPECTIVE SEEMS A BIT STIFF. FOR THAT CHARACTER, I'D...

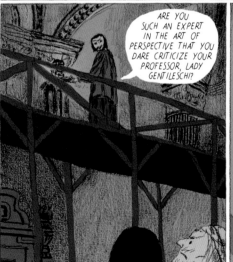

ARE YOU SUCH AN EXPERT IN THE ART OF PERSPECTIVE THAT YOU DARE CRITICIZE YOUR PROFESSOR, LADY GENTILESCHI?

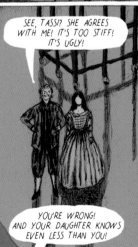

SEE, TASSI? SHE AGREES WITH ME! IT'S TOO STIFF! IT'S UGLY!

YOU'RE WRONG! AND YOUR DAUGHTER KNOWS EVEN LESS THAN YOU!

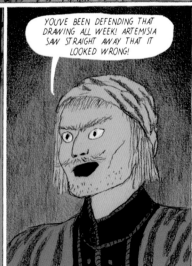

YOU'VE BEEN DEFENDING THAT DRAWING ALL WEEK! ARTEMISIA SAW STRAIGHT AWAY THAT IT LOOKED WRONG!

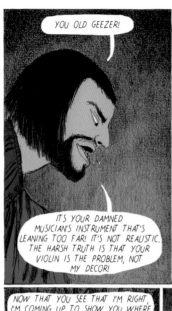

YOU OLD GEEZER!

IT'S YOUR DAMNED MUSICIAN'S INSTRUMENT THAT'S LEANING TOO FAR! IT'S NOT REALISTIC. THE HARSH TRUTH IS THAT YOUR VIOLIN IS THE PROBLEM, NOT MY DECOR!

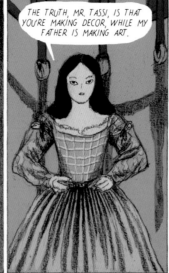

THE TRUTH, MR. TASSI, IS THAT YOU'RE MAKING DECOR, WHILE MY FATHER IS MAKING ART.

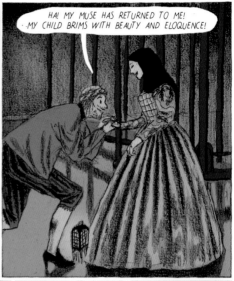

HA! MY MUSE HAS RETURNED TO ME! MY CHILD BRIMS WITH BEAUTY AND ELOQUENCE!

NOW THAT YOU SEE THAT I'M RIGHT, I'M COMING UP TO SHOW YOU WHERE YOUR RAILING IS OFF!

AND YOU'LL FIX IT!

ORAZIO! YOU MUST TAKE ME HOME FIRST!

LATER! WHY DON'T YOU KEEP YOURSELF BUSY WITH SOME CHARCOAL AND PAPER?

BUT I'M HUNGRY! AND I HAVE THAT LITTLE PAINTING TO FINISH AT HOME!

I'LL WALK ARTEMISIA BACK.

DEFINITELY NOT! SHE'LL STAY HERE AND GO BACK HOME WITH ME LATER!

IT'S FINE, I'LL DO IT. I'M HUNGRY TOO!

BUT ARTEMISIA MUST STAY TO HELP ME LOOK AT THIS DRAWING, AND—

IT'S FINE! I'LL TAKE HER HOME, SO YOU CAN WORK LATER, ALRIGHT?

BUT I'M NOT FEEDING YOU!

I FORBID YOU FROM EATING ANY OF MY FOOD! I'M DONE FOOTING YOUR BILLS!

YOU'RE A THIEF, TASSI. I'M SURE OF IT.

A THIEF!

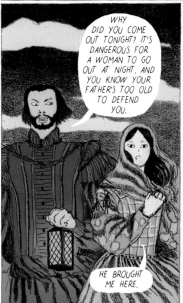

WHY DID YOU COME OUT TONIGHT? IT'S DANGEROUS FOR A WOMAN TO GO OUT AT NIGHT. AND YOU KNOW YOUR FATHER'S TOO OLD TO DEFEND YOU.

HE BROUGHT ME HERE.

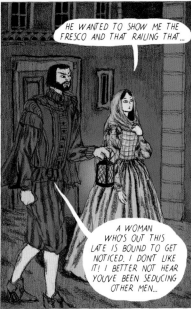

HE WANTED TO SHOW ME THE FRESCO AND THAT RAILING THAT...

A WOMAN WHO'S OUT THIS LATE IS BOUND TO GET NOTICED. I DON'T LIKE IT! I BETTER NOT HEAR YOU'VE BEEN SEDUCING OTHER MEN...

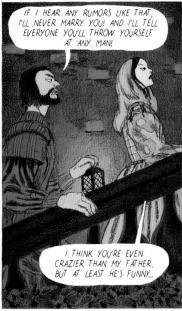

IF I HEAR ANY RUMORS LIKE THAT, I'LL NEVER MARRY YOU! AND I'LL TELL EVERYONE YOU'LL THROW YOURSELF AT ANY MAN!

I THINK YOU'RE EVEN CRAZIER THAN MY FATHER. BUT AT LEAST HE'S FUNNY...

THERE YOU ARE, GOING ON ABOUT YOUR FATHER AGAIN! WHY DON'T YOU LOOK AT ME THE SAME WAY?

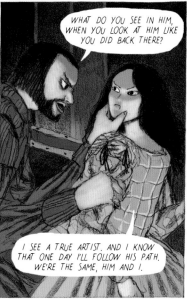

WHAT DO YOU SEE IN HIM, WHEN YOU LOOK AT HIM LIKE YOU DID BACK THERE?

I SEE A TRUE ARTIST. AND I KNOW THAT ONE DAY I'LL FOLLOW HIS PATH. WE'RE THE SAME, HIM AND I.

THAT'S WHY WE LOVE EACH OTHER

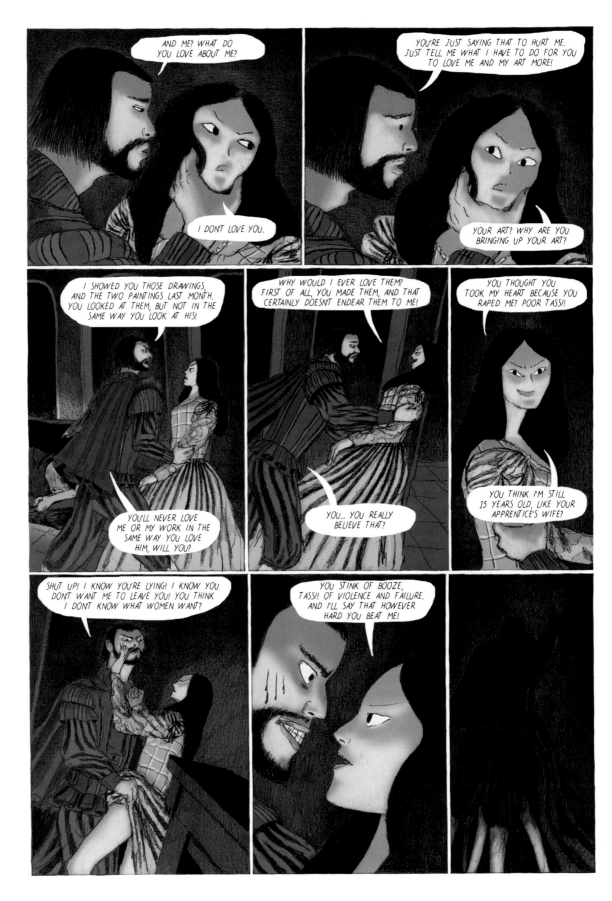

I DONT UNDERSTAND WHY WE DONT GET ALONG. I DONT KNOW WHAT ELSE TO DO... YOU'D BE BETTER OFF LOVING ME INSTEAD OF YOUR FATHER!

YOU KNOW HE'LL ALWAYS SACRIFICE YOU...

DONT TALK ABOUT MY FATHER. YOU KNOW NOTHING.

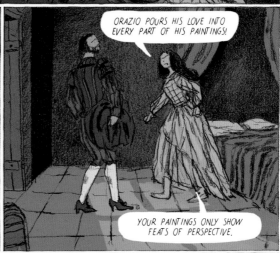

ORAZIO POURS HIS LOVE INTO EVERY PART OF HIS PAINTINGS!

YOUR PAINTINGS ONLY SHOW FEATS OF PERSPECTIVE.

YOU DONT UNDERSTAND THE FIRST THING ABOUT ART OR LOVE! HOW DARE YOU COMPARE YOURSELF TO HIM?

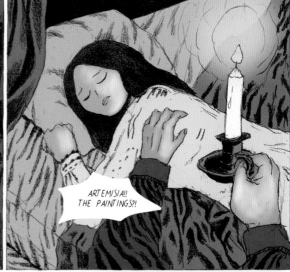

ARTEMISIA!! THE PAINTINGS?!

WHAT?

THE PAINTINGS! DID YOU TAKE THEM?!?

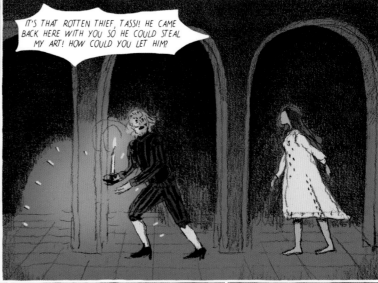

IT'S THAT ROTTEN THIEF, TASSI! HE CAME BACK HERE WITH YOU SO HE COULD STEAL MY ART! HOW COULD YOU LET HIM?

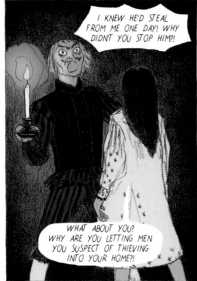

I KNEW HE'D STEAL FROM ME ONE DAY! WHY DIDN'T YOU STOP HIM?!

WHAT ABOUT YOU? WHY ARE YOU LETTING MEN YOU SUSPECT OF THIEVING INTO YOUR HOME?!

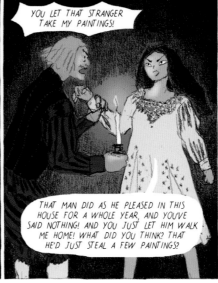

YOU LET THAT STRANGER TAKE MY PAINTINGS!

THAT MAN DID AS HE PLEASED IN THIS HOUSE FOR A WHOLE YEAR, AND YOU'VE SAID NOTHING! AND YOU JUST LET HIM WALK ME HOME! WHAT DID YOU THINK? THAT HE'D JUST STEAL A FEW PAINTINGS?

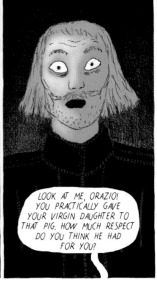

LOOK AT ME, ORAZIO! YOU PRACTICALLY GAVE YOUR VIRGIN DAUGHTER TO THAT PIG. HOW MUCH RESPECT DO YOU THINK HE HAD FOR YOU?

I DON'T WANT TO HEAR WHATEVER IT IS YOU'RE IMPLYING! WHAT I WANT IS FOR HIM TO RETURN MY PAINTINGS!

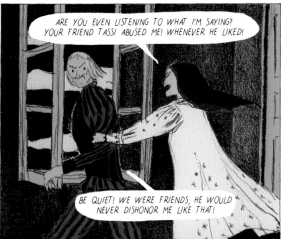

ARE YOU EVEN LISTENING TO WHAT I'M SAYING? YOUR FRIEND TASSI ABUSED ME! WHENEVER HE LIKED!

BE QUIET! WE WERE FRIENDS, HE WOULD NEVER DISHONOR ME LIKE THAT!

YOU?! DISHONORED YOU? IS THAT ALL YOU HAVE TO SAY TO ME?

BE QUIET! I REFUSE TO LISTEN TO THIS.

YOU ALREADY KNEW, DIDN'T YOU? YOU KNEW FROM THE START!

LET ME BE!

AND I THOUGHT I HAD TO SPARE YOU! I THOUGHT YOU WERE TOO WEAK! THAT YOU COULD NEVER WORK AGAIN, OR YOU'D PROVOKE TASSI INTO GOD KNOWS WHAT...

SO I STAYED QUIET... I WAS ASHAMED!

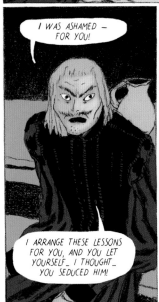

I WAS ASHAMED — FOR YOU!

I ARRANGE THESE LESSONS FOR YOU, AND YOU LET YOURSELF... I THOUGHT... YOU SEDUCED HIM!

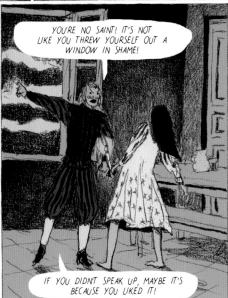

YOU'RE NO SAINT! IT'S NOT LIKE YOU THREW YOURSELF OUT A WINDOW IN SHAME!

IF YOU DIDN'T SPEAK UP, MAYBE IT'S BECAUSE YOU LIKED IT!

ENOUGH!!!

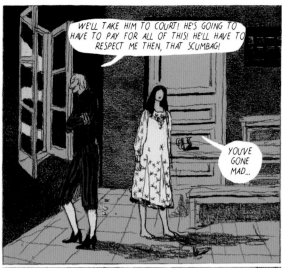

WE'LL TAKE HIM TO COURT! HE'S GOING TO HAVE TO PAY FOR ALL OF THIS! HE'LL HAVE TO RESPECT ME THEN, THAT SCUMBAG!

YOU'VE GONE MAD...

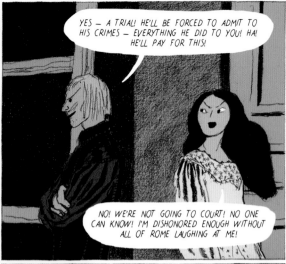

YES — A TRIAL! HE'LL BE FORCED TO ADMIT TO HIS CRIMES — EVERYTHING HE DID TO YOU! HA! HE'LL PAY FOR THIS!

NO! WE'RE NOT GOING TO COURT! NO ONE CAN KNOW! I'M DISHONORED ENOUGH WITHOUT ALL OF ROME LAUGHING AT ME!

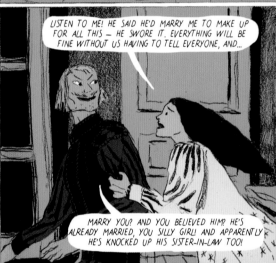

LISTEN TO ME! HE SAID HE'D MARRY ME TO MAKE UP FOR ALL THIS — HE SWORE IT. EVERYTHING WILL BE FINE WITHOUT US HAVING TO TELL EVERYONE, AND...

MARRY YOU? AND YOU BELIEVED HIM? HE'S ALREADY MARRIED, YOU SILLY GIRL! AND APPARENTLY HE'S KNOCKED UP HIS SISTER-IN-LAW TOO!

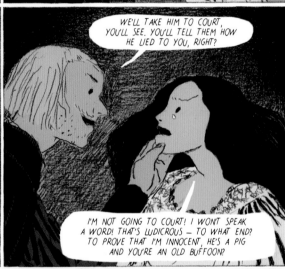

WE'LL TAKE HIM TO COURT, YOU'LL SEE. YOU'LL TELL THEM HOW HE LIED TO YOU, RIGHT?

I'M NOT GOING TO COURT! I WON'T SPEAK A WORD! THAT'S LUDICROUS — TO WHAT END? TO PROVE THAT I'M INNOCENT, HE'S A PIG AND YOU'RE AN OLD BUFFOON?

YOU'LL BEHAVE AS YOU'RE TOLD! YOU SHOULDN'T HAVE LET HIM DO WHAT HE DID TO YOU! YOU'RE A FOOL FOR KEEPING A MAN LIKE THAT COMPANY! AND I HOPE YOU'RE NOT CONSPIRING WITH HIM ABOUT MY PAINTINGS!

HE'S DRIVEN YOU MAD. I WILL NOT GO TO COURT. NEVER, I'D RATHER THROW MYSELF OFF THE ROOF.

NEVER, YOU HEAR ME?

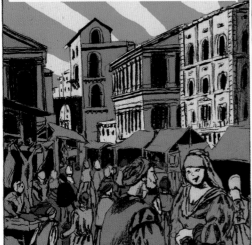

WELL PRUDENZIA, YOU KNOW THE REST OF THE STORY AS WELL AS EVERYONE ELSE: OLD ORAZIO WAS STUBBORN, AND IN MARCH OF 1612, HE FILED THE CLAIM IN COURT. THEY THREW TASSI IN JAIL TO AWAIT HIS JUDGEMENT, AND THE CASE BECAME THE TALK OF THE TOWN.

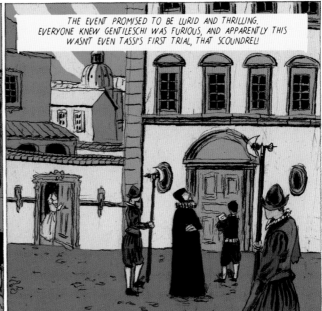

THE EVENT PROMISED TO BE LURID AND THRILLING. EVERYONE KNEW GENTILESCHI WAS FURIOUS, AND APPARENTLY THIS WASN'T EVEN TASSI'S FIRST TRIAL, THAT SCOUNDREL!

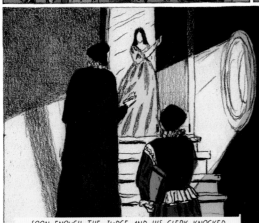

SOON ENOUGH, THE JUDGE AND HIS CLERK KNOCKED ON THE PLAINTIFF'S DOOR TO INTERROGATE THE GIRL AT THE CENTER OF IT ALL.

EVERYTHING HAD TO BE RECOUNTED — EVERY WORD, EVERY ACT, EVERY GESTURE, IN PRECISE LANGUAGE. IT ALL HAD TO BE RELIVED DOWN TO THE MOST MINUTE DETAIL.

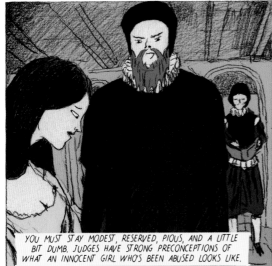

YOU MUST STAY MODEST, RESERVED, PIOUS, AND A LITTLE BIT DUMB. JUDGES HAVE STRONG PRECONCEPTIONS OF WHAT AN INNOCENT GIRL WHO'S BEEN ABUSED LOOKS LIKE.

THEIR PRINCIPAL TASK IS TO JUDGE WHETHER THEY ARE IN FRONT OF A VENGEFUL WOMAN OR A MARTYRED YOUNG GIRL. THIS DECISION WILL DETERMINE THE ENTIRETY OF THE REMAINDER OF THE TRIAL.

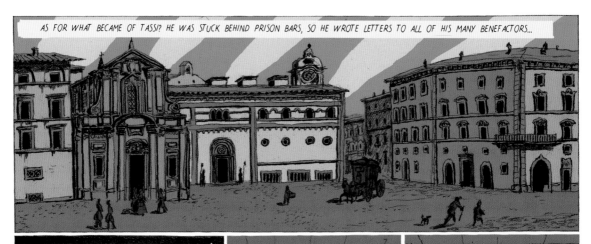

AS FOR WHAT BECAME OF TASSI? HE WAS STUCK BEHIND PRISON BARS, SO HE WROTE LETTERS TO ALL OF HIS MANY BENEFACTORS...

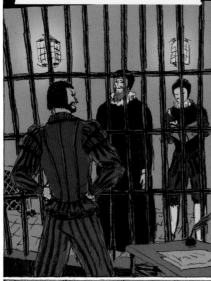

HE WAS FRUSTRATED AND ENRAGED. HE MAINTAINED HIS INNOCENCE IN EACH INTERROGATION. HE SAID GENTILESCHI OWED HIM MONEY, AND HAD HAD HIM LOCKED UP TO AVOID PAYING HIM BACK! AND THAT ARTEMISIA WAS JUST SOME LUSTY WENCH...

SOME WITNESSES SAID HE WAS MARRIED, AND OTHERS SAID HE WAS WIDOWED. SOME SAID HE'D HAD HIS WIFE ASSASSINATED IN LIVORNO!

MURDEROUS! AND INCESTUOUS, TOO! FOR WASN'T THAT FRIGHTFULLY YOUNG GIRL WHO LIVED IN HIS HOUSE THE SISTER OF HIS SLAUGHTERED WIFE?

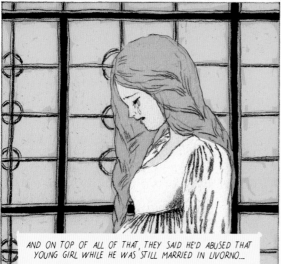

AND ON TOP OF ALL OF THAT, THEY SAID HE'D ABUSED THAT YOUNG GIRL WHILE HE WAS STILL MARRIED IN LIVORNO....

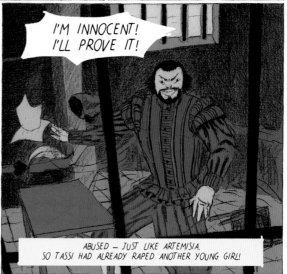

I'M INNOCENT! I'LL PROVE IT!

ABUSED — JUST LIKE ARTEMISIA. SO TASSI HAD ALREADY RAPED ANOTHER YOUNG GIRL!

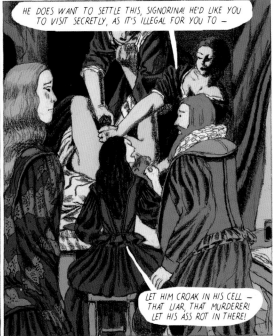

HE DOES WANT TO SETTLE THIS, SIGNORINA! HE'D LIKE YOU TO VISIT SECRETLY, AS IT'S ILLEGAL FOR YOU TO —

LET HIM CROAK IN HIS CELL — THAT LIAR, THAT MURDERER! LET HIS ASS ROT IN THERE!

SIGNORINA! YOU SHOULDN'T WISH SUCH THINGS! IT WOULD BE BEST TO FIND AN HONORABLE AGREEMENT— FOR HIM, BUT ESPECIALLY FOR YOU! WHAT WOULD BECOME OF YOU WERE HE TO DIE?

HE CERTAINLY HAS A GOOD FRIEND IN YOU, AND A GREAT LAWYER!

HE IS NO FRIEND OF MINE. AND IF WHAT THEY SAY IS TRUE, HE'S A REAL DEGENERATE. BUT HE ASKED FOR THIS FAVOR, AND I AM NOT A MAN TO REFUSE HELPING A WRETCH.

YOU! DON'T YOU DARE TOUCH MY PAINTING!!

THIS IS MY NEPHEW, SIGNORINA. HE IS ALSO A PAINTER, FROM FLORENCE, AND HE—

I DON'T CARE! NO ONE TOUCHES MY PAINTINGS!

SORRY...

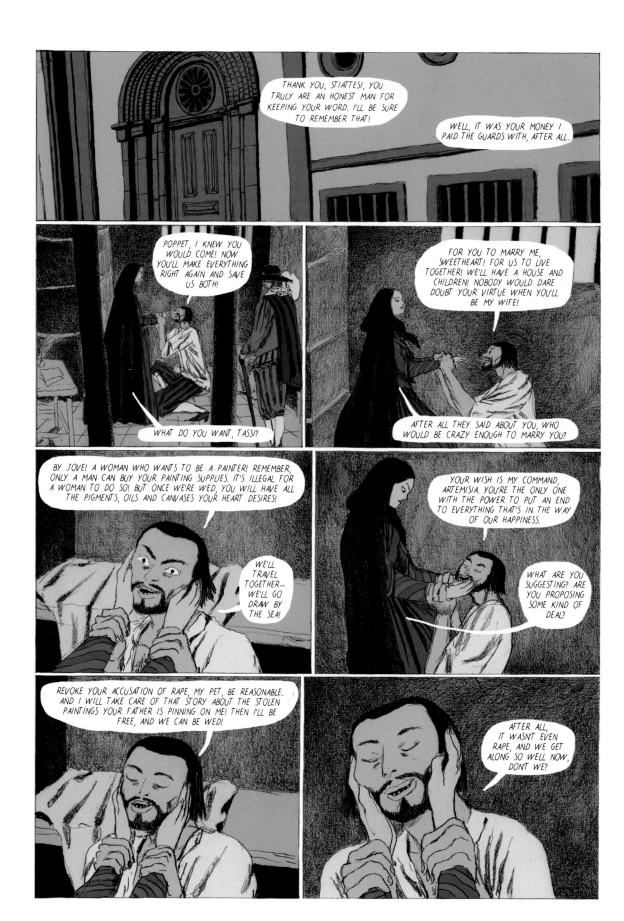

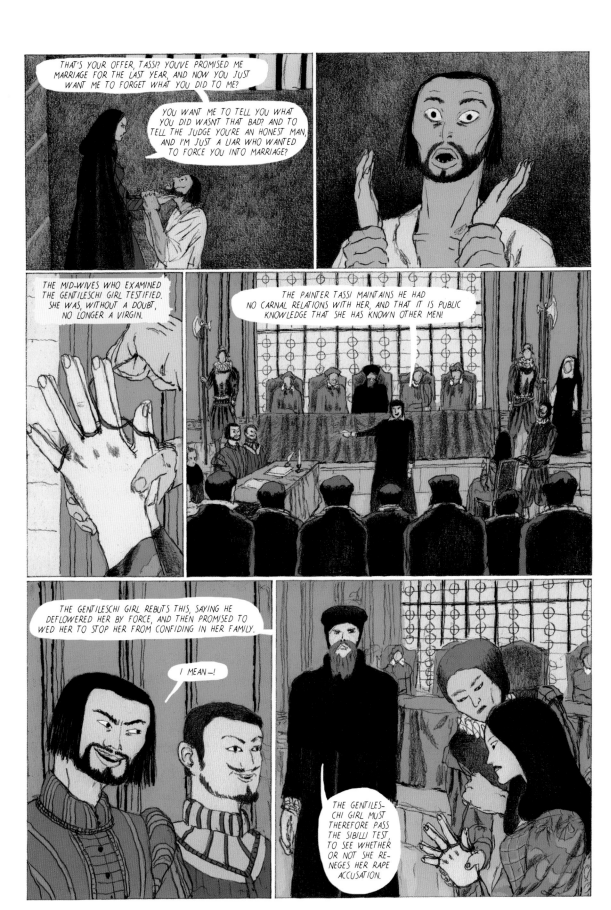

59

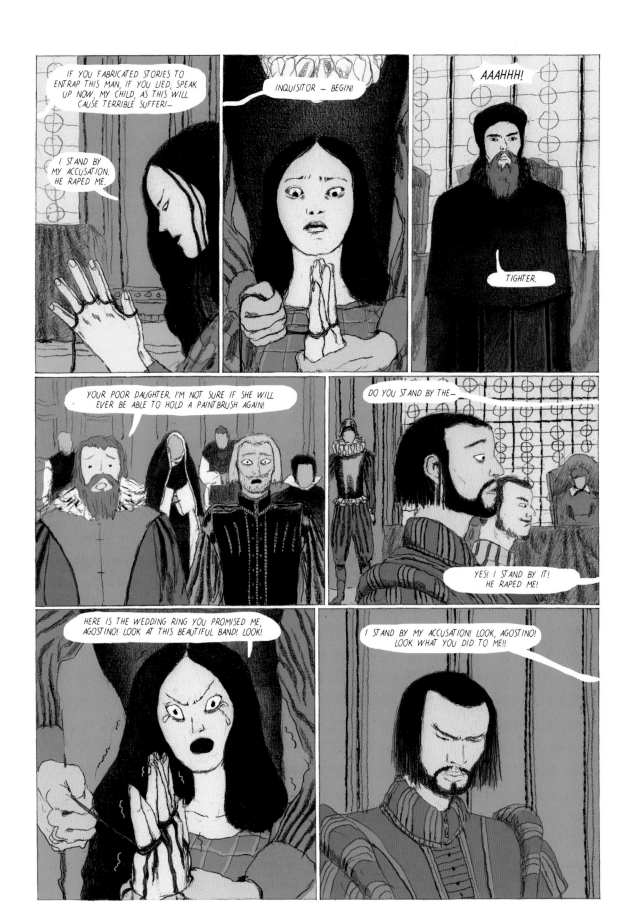

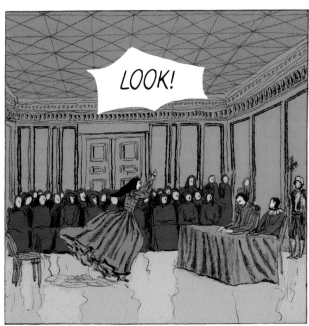

LOOK!

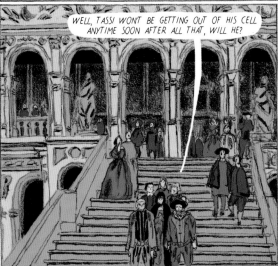

WELL, TASSI WON'T BE GETTING OUT OF HIS CELL ANYTIME SOON AFTER ALL THAT, WILL HE?

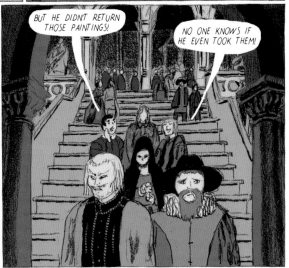

BUT HE DIDN'T RETURN THOSE PAINTINGS!

NO ONE KNOWS IF HE EVEN TOOK THEM!

WELL, YOU GOT WHAT YOU WANTED, MASTER GENTILESCHI! I HOPE THAT IT DIDN'T END UP COSTING YOU TOO MUCH...

HMM...

LET US DINE TOGETHER! ALLOW ME TO INVITE YOU TO THE TAVERN!

AS LONG AS YOU AREN'T AFRAID OF BEING SEEN IN OUR COMPANY...

YOU ARE A COMPLICATED MAN, SIR! BUT A MAN OF THE HEART, OF THAT I'M SURE!

I CAN SEE THE DILEMMA YOU'RE IN! HOW YOU KNOW WHAT AWAITS YOUR DAUGHTER EVEN AFTER WHAT'S JUST HAPPENED TO HER!

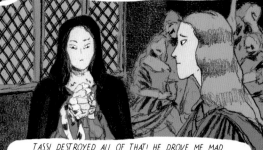

MY DAUGHTER WAS A JEWEL! BEAUTIFUL, AND LOVING, AND HER PAINTINGS SHOWED MORE TALENT AND GUTS THAN ANY OF YOUR FLORENTINE PAINTERS! SHE WAS A PROUD ROMAN!

TASSI DESTROYED ALL OF THAT! HE DROVE ME MAD WITH HIS FLATTERY, HIS SCHEMES, AND HIS PAINTINGS. MY AMBITION MADE ME BLIND AND STUPID.

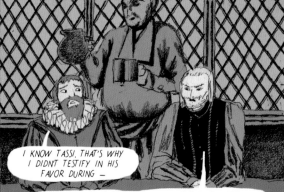

I KNOW TASSI. THAT'S WHY I DIDNT TESTIFY IN HIS FAVOR DURING —

TASSI RUINED EVERYTHING. MY DAUGHTER IS WORTH LESS THAN A PROSTITUTE NOW. YOU SAW HOW SHE WAS TREATED IN THE STREET EARLIER!

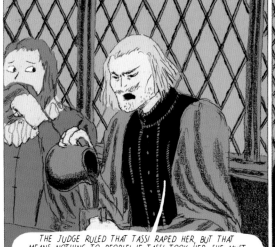

THE JUDGE RULED THAT TASSI RAPED HER, BUT THAT MEANS NOTHING TO PEOPLE! IF TASSI TOOK HER, SHE MUST HAVE LED HIM ON. SHE LET HIM DO IT! AND IF SHE DIDNT KILL HERSELF AFTERWARDS, IT MEANS SHE LIKED IT! AND IF IT KEPT HAPPENING? THEN SHE'S A WHORE!

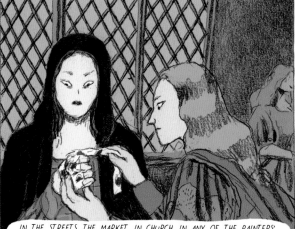

IN THE STREETS, THE MARKET, IN CHURCH, IN ANY OF THE PAINTERS' AND PATRONS' TAVERNS, SHE'S NO LONGER A GOOD GIRL. SHE'S NOT EVEN A PAINTER. NOW SHE'S JUST TASSI'S WHORE. SO THE PATH THAT AWAITS HER IS THE ONLY ONE AVAILABLE IN THESE SITUATIONS: THE CONVENT! LET'S HOPE SHE CAN ATONE FOR ALL HER SINS THERE!

OR MARRIAGE.

SURELY YOU JEST! WHO WOULD WANT HER NOW?

A YOUNG MAN IN LOVE WOULD WED HER!

LIKE MY NEPHEW PIERANTONIO. HE'LL CARE FOR HER — THEY'LL LIVE IN FLORENCE WITH MY FAMILY.

AND IF WHAT YOU SAY IS TRUE, AND HER TALENT SURPASSES ALL THE PAINTERS IN FLORENCE, THEN THEIR FUTURE IS SECURE.

I DON'T KNOW. WHAT A CRUEL DECISION FATE ASKS OF ME! THEN AGAIN... WHY NOT?

WELL, THERE IS NO DOWRY TO COLLECT, SO THE WEDDING CAN OCCUR WHENEVER YOUR NEPHEW PLEASES.

LET'S HOPE HE ACCEPTS!

NOVEMBER 1612

HURRY, CHILDREN! YOUR CARRIAGE AWAITS. YOU'LL CATCH UP WITH YOUR FLORENCE-BOUND TRUNKS AT THE INN TONIGHT!

BE GOOD, YOU TWO! I DON'T KNOW WHEN WE'LL SEE EACH OTHER AGAIN!

NOW THAT YOU'RE LEAVING, HE'LL ACTUALLY HAVE TO MAKE PAINTERS OUT OF US!

GOODBYE, ORAZIO...

GOODBYE, CHILD.

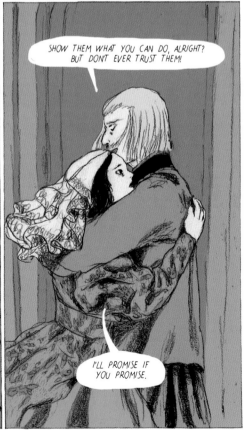

SHOW THEM WHAT YOU CAN DO, ALRIGHT? BUT DON'T EVER TRUST THEM!

I'LL PROMISE IF YOU PROMISE.

AND THAT, MY DEAR PRUDENZIA, IS HOW YOUR FATHER AND MOTHER WERE WED —
RIGHT AFTER THAT INFAMOUS TRIAL, AND RIGHT BEFORE THEIR LONG ROAD OUT OF ROME.

TAKE CARE, MY POOR SWEET FATHER...

COME NOW, GENTILESCHI! ALL FATHERS LOSE THEIR DAUGHTERS EVENTUALLY! BUT YOU'VE NOT LOST EVERY-THING — WE'RE ONE BIG FAMILY NOW!

MY DAUGHTER — YOU STOLE HER FROM ME! YOU AND EVERYONE ELSE!

OUT OF MY SIGHT, YOU LOUSE!

FRANCESCO! MARCO! LET'S GO! STOP DAWDLING — YOU ALREADY WORK AT A SNAIL'S PACE!

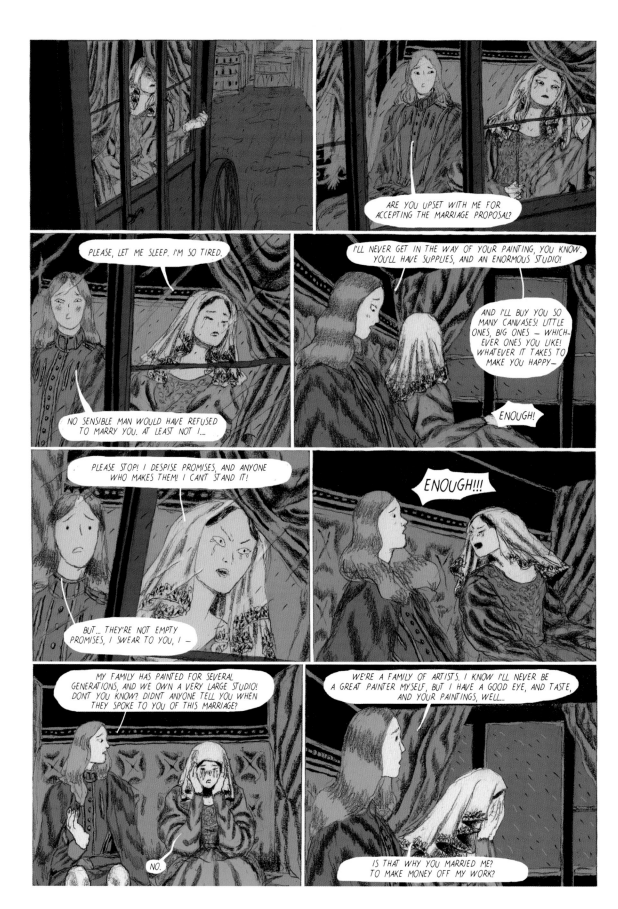

66

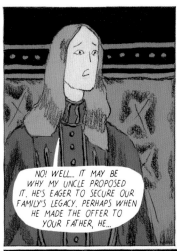

NO! WELL... IT MAY BE WHY MY UNCLE PROPOSED IT. HE'S EAGER TO SECURE OUR FAMILY'S LEGACY. PERHAPS WHEN HE MADE THE OFFER TO YOUR FATHER, HE...

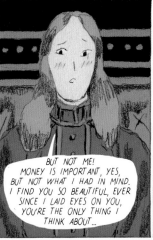

BUT NOT ME! MONEY IS IMPORTANT, YES, BUT NOT WHAT I HAD IN MIND. I FIND YOU SO BEAUTIFUL, EVER SINCE I LAID EYES ON YOU, YOU'RE THE ONLY THING I THINK ABOUT...

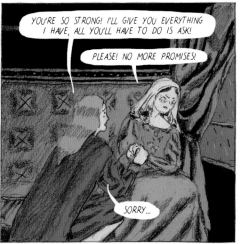

YOU'RE SO STRONG! I'LL GIVE YOU EVERYTHING I HAVE, ALL YOU'LL HAVE TO DO IS ASK!

PLEASE! NO MORE PROMISES!

SORRY...

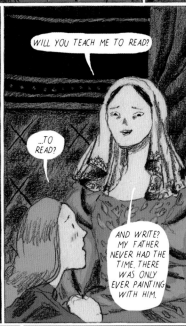

WILL YOU TEACH ME TO READ?

...TO READ?

AND WRITE? MY FATHER NEVER HAD THE TIME. THERE WAS ONLY EVER PAINTING WITH HIM.

WHEN I WAS IN SCHOOL, I WAS TOP OF MY CLASS IN WRITING. AND I HAVE A LOT OF BOOKS, TOO, YOU'LL SEE!

YOU SHOULD LEARN LATIN AS WELL! WHEN COLLECTORS VISIT THEY SPEAK LATIN AMONGST THEMSELVES TO INTIMIDATE THE PAINTERS, BUT WE WON'T LET THEM GET AWAY WITH IT! I'LL TEACH YOU LATIN TOO, IF YOU LIKE!

SOUNDS LIKE I'M GOING TO BE QUITE A SCHOLAR!

YOU'RE BRILLIANT ALREADY. IT'LL BE EASY, AND I'M SURE WE'LL HAVE GOOD TIME!

TELL ME ABOUT YOUR HOUSE WITH THE LARGE STUDIO, AND THE NEIGHBORHOOD YOU LIVE IN.

TELL ME ABOUT FLORENCE TOO — BUT DON'T MAKE ME ANY PROMISES!

YOU HAVE MY WORD! I MEAN... YES!

WHY WOULD YOU DO THAT? LEAVING BEFORE DAWN SO THAT I HAD TO CHASE AFTER YOU!

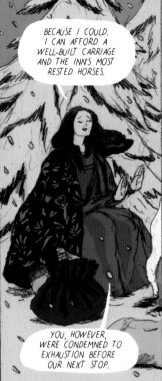

BECAUSE I COULD. I CAN AFFORD A WELL-BUILT CARRIAGE AND THE INN'S MOST RESTED HORSES.

YOU, HOWEVER, WERE CONDEMNED TO EXHAUSTION BEFORE OUR NEXT STOP.

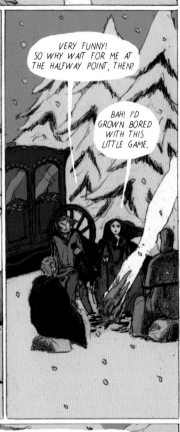

VERY FUNNY! SO WHY WAIT FOR ME AT THE HALFWAY POINT, THEN?

BAH! I'D GROWN BORED WITH THIS LITTLE GAME.

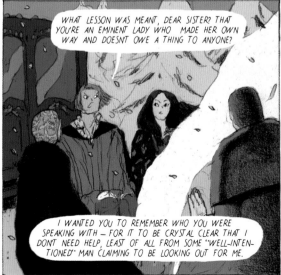

WHAT LESSON WAS MEANT, DEAR SISTER? THAT YOU'RE AN EMINENT LADY WHO MADE HER OWN WAY AND DOESN'T OWE A THING TO ANYONE?

I WANTED YOU TO REMEMBER WHO YOU WERE SPEAKING WITH — FOR IT TO BE CRYSTAL CLEAR THAT I DON'T NEED HELP, LEAST OF ALL FROM SOME "WELL-INTEN-TIONED" MAN CLAIMING TO BE LOOKING OUT FOR ME.

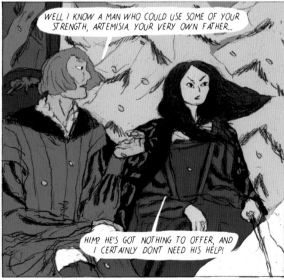

WELL I KNOW A MAN WHO COULD USE SOME OF YOUR STRENGTH, ARTEMISIA. YOUR VERY OWN FATHER...

HIM? HE'S GOT NOTHING TO OFFER, AND I CERTAINLY DON'T NEED HIS HELP!

I REFUSE TO CARE FOR HIM WHEN HE GETS OLD! I HAVE MY OWN CHILDREN TO WED, AND MY OWN LIFE TO LIVE!

I KNOW HE BADMOUTHS MY WORK! I'VE HEARD WHAT HE SAYS IN PUBLIC! HE CLAIMS I COPY HIM!? HA! RIGHT! TELL HIM I KNOW WHAT HE'S SAID!

HMM... I'M SURE HE KNOWS YOU KNOW. YOU TWO ARE SO MUCH ALIKE.

BAH! WHAT A PAIN IN THE ASS THIS FAMILY IS!

DO YOU WANT ANY BREAD? I BOUGHT THREE POUNDS AT THE INN. I DIDN'T THINK I'D CATCH UP WITH YOU SO QUICKLY... IF YOU HAVE ANYTHING TO DRINK...

SURE. WE HAVE WINE. AND SOME FRUIT, TOO.

YOU DESPISE ALL OF US FOR NO REASON, LITTLE SISTER. FATHER, FRANCESCO AND I ARE BORING, JUST LIKE EVERYONE ELSE. YOU'RE THE SPECIAL ONE. GOOD FOR YOU, I GUESS. IT LOOKS LIKE IT SERVED YOU WELL IN THE END.

BETTER THAN YOUR HUSBAND, AT LEAST...

BUT THAT DOPE WASN'T ALL THAT SPECIAL IN THE END EITHER, RIGHT?

PRUDENZIA, GO GET SOME REST IN THE CARRIAGE. AND MARCO... YOU'D BETTER WATCH YOUR MOUTH BEFORE MY COACHMAN KNOCKS IT INTO THE FIRE...

HUMPH! FINE. LET'S RETURN TO THE CONVERSATION AT HAND. I'VE COME TO SPEAK WITH YOU ABOUT FATHER.

BELIEVE ME, ARTEMISIA, HE NEEDS YOU. HE'S OLD NOW. YOU'RE THE ONLY ONE WHO CAN SAVE HIM, YOU KNOW.

I CAN'T HELP HIM. AND I WON'T GO TO ROME TO SEE HIM.

HE DIDN'T RETURN TO ROME! I THOUGHT YOU WERE MORE UP TO DATE. HE LEFT FOR LONDON, AND HAS STAYED THERE SINCE. FRANCESCO AND I TRAVEL AROUND FOR HIS COMMISSIONS. LET ME TELL YOU ABOUT THE LAST FEW YEARS....

PLEASE TELL ME MORE. WHAT ABOUT MY FATHER? DID MY PARENTS LOVE ONE ANOTHER? WERE THEY EVER HAPPY?

WHAT? HAPPY? WHY... YES, I'M SURE THEY WERE. WHY NOT? THEY WERE YOUNG AND BEAUTIFUL, AND FORTUNE FAVORED THEM EARLY ON!

I DON'T KNOW EVERYTHING — I ONLY CAME INTO THEIR LIVES THE FOLLOWING SPRING. IN ANY CASE, HE WAS TRUE TO HIS WORD, AND TAUGHT HER EVERYTHING HE KNEW.

READING, WRITING, MATH, SHE LEARNED IT ALL SO QUICKLY! SHE WAS THE MOST EAGER STUDENT IN ALL OF FLORENCE!

AND LATIN?

OH, WELL... THERE WASN'T MUCH NEED FOR IT...

THEY LIVED TOGETHER AT THE STIATTESI'S, WHO CLEARLY GOT A BARGAIN! FOR THE PRICE OF ONE NEATLY FURNISHED ROOM, ARTEMISIA WORKED ENDLESSLY. THOSE STUDIOS HAD NEVER SEEN SO MANY PAINTINGS, CANVASES, AND BUYERS!

PIERANTONIO BOUGHT THE CANVASES, AND HIS WIFE PAINTED...

...AND ALL THE INCOME FROM THOSE PAINTINGS WENT STRAIGHT INTO THE FAMILY COFFERS!

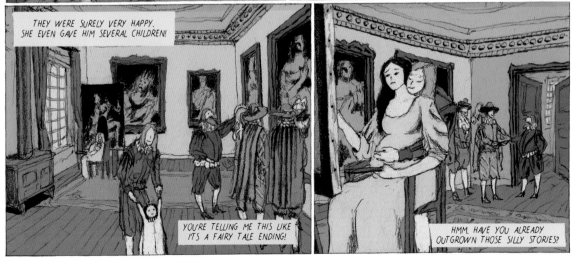

THEY WERE SURELY VERY HAPPY. SHE EVEN GAVE HIM SEVERAL CHILDREN!

YOU'RE TELLING ME THIS LIKE IT'S A FAIRY TALE ENDING!

HMM. HAVE YOU ALREADY OUTGROWN THOSE SILLY STORIES?

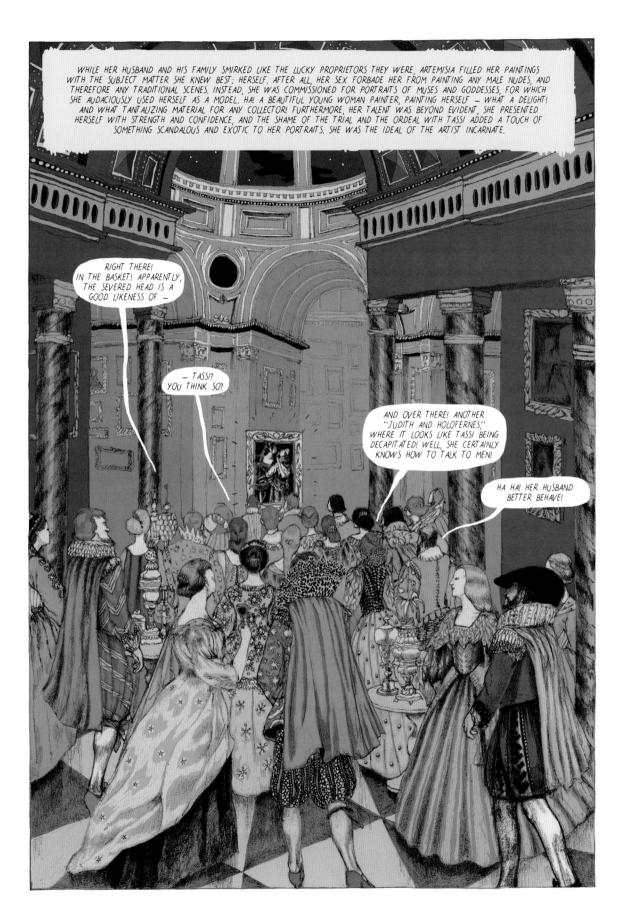

WHILE HER HUSBAND AND HIS FAMILY SMIRKED LIKE THE LUCKY PROPRIETORS THEY WERE, ARTEMISIA FILLED HER PAINTINGS WITH THE SUBJECT MATTER SHE KNEW BEST: HERSELF. AFTER ALL, HER SEX FORBADE HER FROM PAINTING ANY MALE NUDES, AND THEREFORE ANY TRADITIONAL SCENES. INSTEAD, SHE WAS COMMISSIONED FOR PORTRAITS OF MUSES AND GODDESSES, FOR WHICH SHE AUDACIOUSLY USED HERSELF AS A MODEL. HA! A BEAUTIFUL YOUNG WOMAN PAINTER, PAINTING HERSELF — WHAT A DELIGHT! AND WHAT TANTALIZING MATERIAL FOR ANY COLLECTOR! FURTHERMORE, HER TALENT WAS BEYOND EVIDENT, SHE PRESENTED HERSELF WITH STRENGTH AND CONFIDENCE, AND THE SHAME OF THE TRIAL AND THE ORDEAL WITH TASSI ADDED A TOUCH OF SOMETHING SCANDALOUS AND EXOTIC TO HER PORTRAITS. SHE WAS THE IDEAL OF THE ARTIST INCARNATE.

RIGHT THERE! IN THE BASKET! APPARENTLY, THE SEVERED HEAD IS A GOOD LIKENESS OF —

— TASSI? YOU THINK SO?

AND OVER THERE! ANOTHER "JUDITH AND HOLOFERNES," WHERE IT LOOKS LIKE TASSI BEING DECAPITATED! WELL, SHE CERTAINLY KNOWS HOW TO TALK TO MEN!

HA HA! HER HUSBAND BETTER BEHAVE!

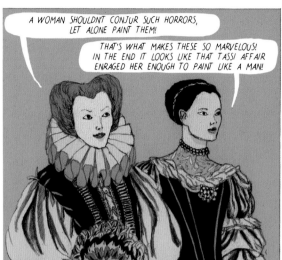

A WOMAN SHOULDNT CONJUR SUCH HORRORS, LET ALONE PAINT THEM!

THAT'S WHAT MAKES THESE SO MARVELOUS! IN THE END IT LOOKS LIKE THAT TASSI AFFAIR ENRAGED HER ENOUGH TO PAINT LIKE A MAN!

AND IT MADE HER FAMOUS. WITHOUT IT SHE'D ONLY BE PAINTING APPLES AND GRAPES IN A BOWL — OR BABY PORTRAITS AT BEST!

YES, MY HUSBAND THINKS SO TOO. SHE REALLY OWES HIM A LOT AT THE END OF THE DAY!

THERE SHE IS!

IS SHE TALKING TO HER HUSBAND?

HEAVENS, NO! THAT'S BUONARROTI THE YOUNGER — MICHAELANGELO'S NEPHEW! HE'S VERY WEALTHY, AND IS WORKING TO BUILD A MUSEUM IN HIS UNCLE'S HONOR!

SEE? HER HUSBAND'S BEHIND THEM, AND CLEARLY NOT QUITE AS BRIGHT A STAR AS THEM, DONT YOU THINK?

GOODNESS, HIS CLOTHES DO LOOK EXPENSIVE, THOUGH! SHE CERTAINLY KEEPS HIM WELL ADORNED!

WELL, AS LONG AS HE KEEPS PLAYING HIS PART, SHE'S HAPPY. IT'LL ONLY LAST AS LONG AS HE CAN ENDURE IT. WHO WOULD WANT TO BE THAT WOMAN'S HUSBAND FOR LONG?

STIATTESI! COME HERE, LAD!

YOUR EXCELLENCY?

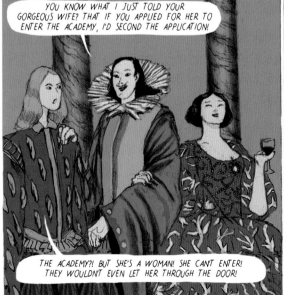

YOU KNOW WHAT I JUST TOLD YOUR GORGEOUS WIFE? THAT IF YOU APPLIED FOR HER TO ENTER THE ACADEMY, I'D SECOND THE APPLICATION!

THE ACADEMY?! BUT SHE'S A WOMAN! SHE CANT ENTER! THEY WOULDNT EVEN LET HER THROUGH THE DOOR!

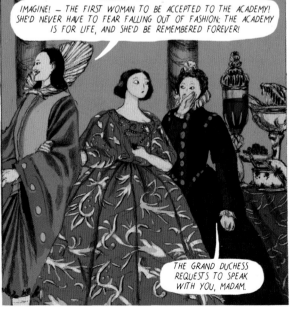

IMAGINE! — THE FIRST WOMAN TO BE ACCEPTED TO THE ACADEMY! SHE'D NEVER HAVE TO FEAR FALLING OUT OF FASHION: THE ACADEMY IS FOR LIFE, AND SHE'D BE REMEMBERED FOREVER!

THE GRAND DUCHESS REQUESTS TO SPEAK WITH YOU, MADAM.

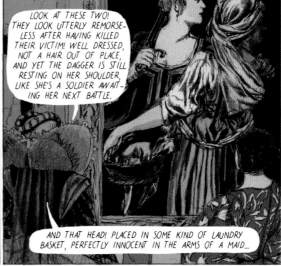

LOOK AT THESE TWO! THEY LOOK UTTERLY REMORSE-LESS AFTER HAVING KILLED THEIR VICTIM! WELL DRESSED, NOT A HAIR OUT OF PLACE, AND YET THE DAGGER IS STILL RESTING ON HER SHOULDER, LIKE SHE'S A SOLDIER AWAIT-ING HER NEXT BATTLE.

MADAM, YOU ARE A VERITABLE INCENDIARY! YOU WHO PAINTS THESE TERRIBLE WOMEN!

AND THAT HEAD! PLACED IN SOME KIND OF LAUNDRY BASKET, PERFECTLY INNOCENT IN THE ARMS OF A MAID...

IT'S MORE OF A FRUIT BASKET, MILADY!

HA! AND I HEARD YOU NEVER PAINTED STILL LIVES!

REAL FRUIT DOESN'T INTEREST ME MUCH...

HMM...

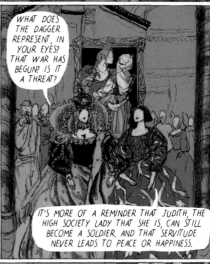

WHAT DOES THE DAGGER REPRESENT, IN YOUR EYES? THAT WAR HAS BEGUN? IS IT A THREAT?

IT'S MORE OF A REMINDER THAT JUDITH, THE HIGH SOCIETY LADY THAT SHE IS, CAN STILL BECOME A SOLDIER. AND THAT SERVITUDE NEVER LEADS TO PEACE OR HAPPINESS.

REVOLUTION DOESN'T LEAD TO HAPPINESS EITHER. AND ITS A SOLITARY ROAD.

I AM NO REVOLUTIONARY! MERELY BORED, AND SURPRISED TO FIND MORE STRENGTH WITHIN THAN I WAS LED TO BELIEVE. IN ANY CASE, SOLITUDE IS AN OLD CHILDHOOD FRIEND.

FOR ME AS WELL.

LISTEN, MY LITTLE INCENDIARY — IF EVER THERE COMES A TIME WHEN MY NAME COULD HELP YOU OUT, MAKE USE OF IT. AND DO TRY TO STAY HAPPY!

WHAT A BORE THAT BUONARROTI FRIEND OF YOURS IS. HE'S OBSESSED WITH THE ACADEMY — WHATEVER FOR?

HE SAYS IT WOULD BE A GREAT ACHIEVEMENT IF I WERE TO—

HA HA!

YOU DON'T NEED THAT! ON THE CONTRARY! SWEETHEART, YOUR PAINTINGS ARE SELLING SO WELL — YOU DON'T NEED ANY JEALOUS OLD GEEZERS COMING TO EXAMINE OR GRADE YOU!

IT COULD BE TERRIBLY EMBARRASSING!

WHAT ARE YOU TALKING ABOUT? I'M NOT SCARED OF THEM!

CLEARLY NOT! YOU HAVE NO SENSE OF... OF PROPRIETY! YOU KNOW WHAT? I FORBID YOU!

FORBID ME? BUT... THEY'RE MY PAINTINGS!

AND I'M YOUR HUSBAND. I KNOW EXACTLY WHAT YOU'RE UP TO.

YOU WANT TO JOIN THE ACADEMY SO THAT YOU WON'T NEED US TO BUY YOUR CANVASES AND PIGMENTS ANY MORE!

WHAT?! YOU'RE DRUNK...

WHEN THE ACADEMY RECOGNIZES A PAINTER THEY'RE GIVEN FULL RIGHTS, EVEN IF THEY'RE A WOMAN. I KNOW IT'S TRUE! YOU WANT TO MAKE ME EVEN MORE USELESS!

IT'S ABOUT TIME! BABY GIRL IS STARVING!

BUT YOU'LL LOSE IT ALL IF YOU GO THROUGH WITH IT, BELIEVE ME! AND IF YOU LOSE ME, YOU'RE DONE FOR!

THIS HAPPENS EVERY TIME YOUR WIFE GOES OUT! ALL THE CHILDREN START CRYING, ESPECIALLY THE BABY.

IT'S FOR HER WORK, MOTHER— THEY ALL WANT TO SEE HER. WE MUST MAKE OCCASIONAL APPEARANCES!

WELL, YOUR WIFE WOULD DO WELL TO STAY HOME MORE OFTEN. THE CHILDREN DON'T LIKE IT!

YOU HEAR THAT, MY PRETTY?

I MADE YOU — AND I FEED YOU LIKE I FEED EVERYONE ELSE AROUND HERE. YET EVEN YOU GET TO DECIDE WHAT I CAN AND CAN'T DO!

BUURP!

THANK YOU, PRUDENZIA, THAT'S EXCELLENT ADVICE!

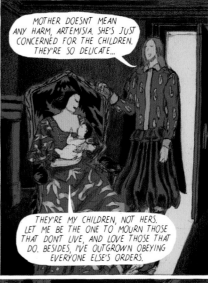

MOTHER DOESN'T MEAN ANY HARM, ARTEMISIA. SHE'S JUST CONCERNED FOR THE CHILDREN. THEY'RE SO DELICATE...

THEY'RE MY CHILDREN, NOT HERS. LET ME BE THE ONE TO MOURN THOSE THAT DON'T LIVE, AND LOVE THOSE THAT DO. BESIDES, I'VE OUTGROWN OBEYING EVERYONE ELSE'S ORDERS.

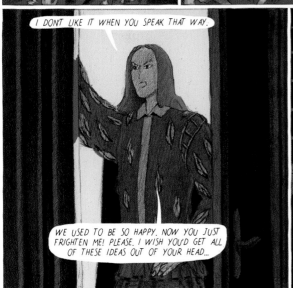

I DON'T LIKE IT WHEN YOU SPEAK THAT WAY.

WE USED TO BE SO HAPPY. NOW YOU JUST FRIGHTEN ME! PLEASE. I WISH YOU'D GET ALL OF THESE IDEAS OUT OF YOUR HEAD...

LIKE I TOLD YOU, PRUDENZIA, THEY WERE HAPPY ONCE. BACK WHEN EVERYTHING WAS STILL NEW BETWEEN THEM, THERE WAS A BRIEF MOMENT WHEN THEY WERE PERFECTLY IN ACCORD WITH ONE ANOTHER, AND THAT'S MORE THAN ENOUGH FOR MOST MARRIAGES.

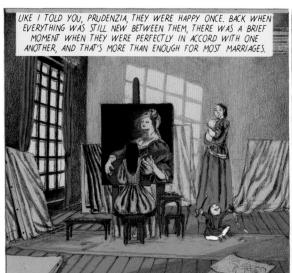

BUT THEN... HE STARTED BECOMING MORE AND MORE LIKE THE OTHER MEN HE KNEW. AND ARTEMISIA HAD FAR GREATER IMAGINATION. SHE ONLY WANTED TO BECOME HERSELF.

MONEY BECAME THEIR UNDOING — BOTH THE MONEY HE COULDN'T EARN, AND THE MONEY SHE WASN'T ALLOWED TO HANDLE.

THEN THEY LOST CHILDREN... IT WAS A TIME WHEN ILLNESS SWEPT THROUGH MUCH OF FLORENCE.

BILLS HAD TO BE PAID. BAILIFFS TOO, ON OCCASION...

I THINK IN THE BEGINNING HE WAS TRYING TO FIND A WAY TO AFFECT HER, TO SHOW HER HE HAD THE POWER TO MAKE HER JEALOUS, OR MISERABLE...

AND WHEN SHE REFUSED TO GIVE HIM THAT SATISFACTION, HE BECAME CRUEL AND POSSESSIVE.

I'VE HAD ENOUGH! I CAN'T TAKE IT!

IN THAT CASE, BELLISSIMA, ALLOW ME TO PLEAD YOUR CASE TO THE ACADEMY! THEN HE WON'T HAVE A SAY ANY LONGER!

HE'LL NEVER FORGIVE ME. HE'S SAID SO. MY LIFE WOULD BECOME EVEN HARDER.

BELLISSIMA! LOOK AT WHAT YOU'VE MADE OF YOUR LIFE ALREADY — HOW FAR YOU'VE COME!

YOUR EXCELLENCY SURELY MEANS HOW MUCH I'VE ENDURED!

HA! STOP FEELING SO SORRY FOR YOURSELF! LOOK AT EVERYTHING YOU'VE BEEN THROUGH. YOU PRACTICALLY RAISED YOURSELF, AND YOU TOOK CARE OF YOUR FATHER. AFTER THAT WHOLE AFFAIR WITH TASSI, YOU SHOULD HAVE ENDED UP IN A NUNNERY OR THE NUT HOUSE — OR THE STREET. BUT NOT YOU. YOU EDUCATED YOURSELF, ENTERED HIGH SOCIETY, AND BECAME A MASTER PAINTER, WITH ONLY YOUR FATHER TO TEACH YOU!

SURELY ONE WHO DID ALL OF THAT CAN DO ANYTHING?

ENOUGH FALSE MODESTY. TELL ME — WHAT IS IT YOU REALLY WANT, ARTEMISIA?

I KNOW I DON'T WANT TO DEPEND ON ANYONE ANYMORE. ASKING PERMISSION FOR EVERYTHING DRIVES ME CRAZY.

AND I WANT TO KEEP PRUDENZIA.

I WANT IT TO BE JUST THE TWO OF US LIVING IN A PEACEFUL HOME, PAINTING ONLY FOR OURSELVES.

THEN LET ME HELP YOU! YOU'LL BECOME THE FIRST WOMAN TO ENTER THE ACADEMY — AND IF YOUR HUSBAND GETS IN THE WAY, I'LL TAKE CARE OF IT.

HA HA! BELLISSIMA, I FEEL AS THOUGH I'M MAKING HISTORY! HOW COMPLETELY DELIGHTFUL!

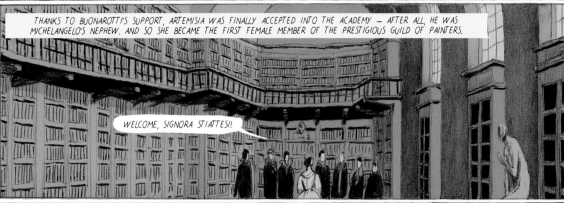

THANKS TO BUONAROTTI'S SUPPORT, ARTEMISIA WAS FINALLY ACCEPTED INTO THE ACADEMY — AFTER ALL, HE WAS MICHELANGELO'S NEPHEW. AND SO SHE BECAME THE FIRST FEMALE MEMBER OF THE PRESTIGIOUS GUILD OF PAINTERS.

WELCOME, SIGNORA STIATTESI!

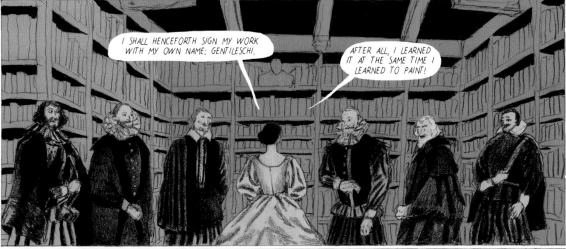

I SHALL HENCEFORTH SIGN MY WORK WITH MY OWN NAME: GENTILESCHI.

AFTER ALL, I LEARNED IT AT THE SAME TIME I LEARNED TO PAINT!

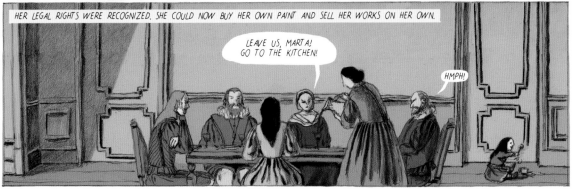

HER LEGAL RIGHTS WERE RECOGNIZED. SHE COULD NOW BUY HER OWN PAINT AND SELL HER WORKS ON HER OWN.

LEAVE US, MARTA! GO TO THE KITCHEN!

HMPH!

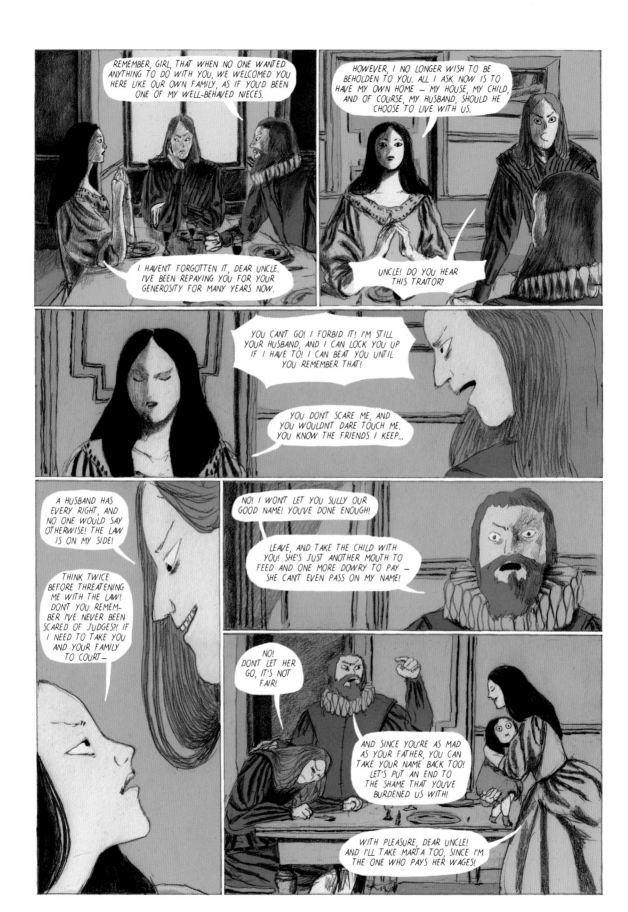

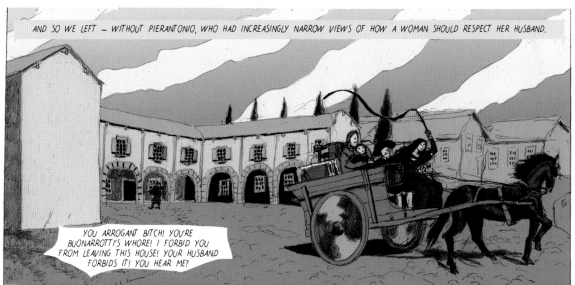

AND SO WE LEFT — WITHOUT PIERANTONIO, WHO HAD INCREASINGLY NARROW VIEWS OF HOW A WOMAN SHOULD RESPECT HER HUSBAND.

YOU ARROGANT BITCH! YOU'RE BUONARROTTI'S WHORE! I FORBID YOU FROM LEAVING THIS HOUSE! YOUR HUSBAND FORBIDS IT! YOU HEAR ME?

I WAS ONLY HER SERVANT, BUT I WAS SURPRISED IT ALL WENT SO SMOOTHLY IN THE END...

DON'T YOU MISS YOUR CHILD TERRIBLY WHILE YOU'RE HERE, MADAM?

WE WORRIED YOU'D BRING IT TO OUR GALLERIES. THANK YOU FOR HAVING THOUGHT TO PRESERVE THE QUIETUDE OF THESE HALLS!

BUT WHEN ONE HAS A FIGURE AS BEAUTIFUL AS YOURS, ONE CAN'T POSSIBLY NEED ALL OF YOUR SKILLS!

THANK YOU! I'LL CONSIDER TEACHING YOU SOME, IT COULD BE USEFUL TO YOU SOMEDAY!

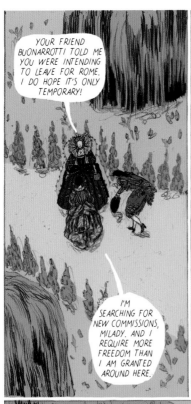

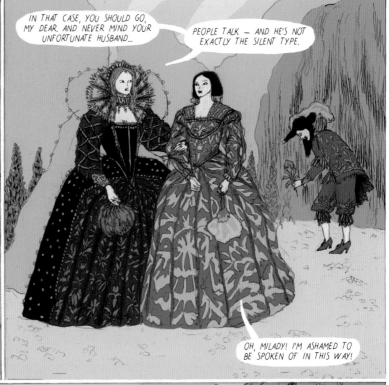

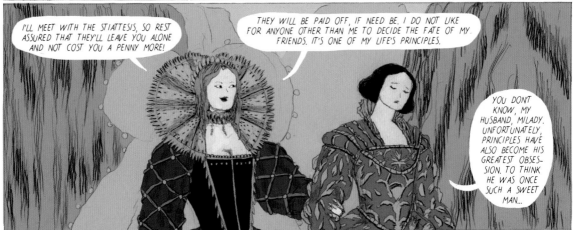

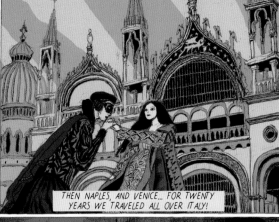

AND SO, YET AGAIN, WE DID AS ARTEMISIA LIKED, AND WE LEFT FOR ROME A FEW MONTHS LATER!

THEN NAPLES, AND VENICE... FOR TWENTY YEARS WE TRAVELED ALL OVER ITALY!

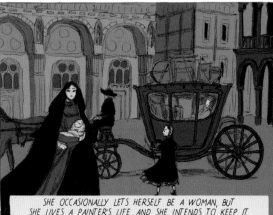

SHE OCCASIONALLY LETS HERSELF BE A WOMAN, BUT SHE LIVES A PAINTER'S LIFE, AND SHE INTENDS TO KEEP IT THAT WAY. SO SHE REMAINS ALONE.

I DON'T THINK SHE HAS ANY REGRETS ABOUT IT ALL...

SHE SAYS SHE DOESN'T NEED A MAN — AT LEAST NOT FOR LONG! AND I BELIEVE HER.

EVER SINCE WE LEFT FLORENCE, IT'S JUST BEEN US ON OUR OWN. AND WE'RE QUITE HAPPY, AREN'T WE?

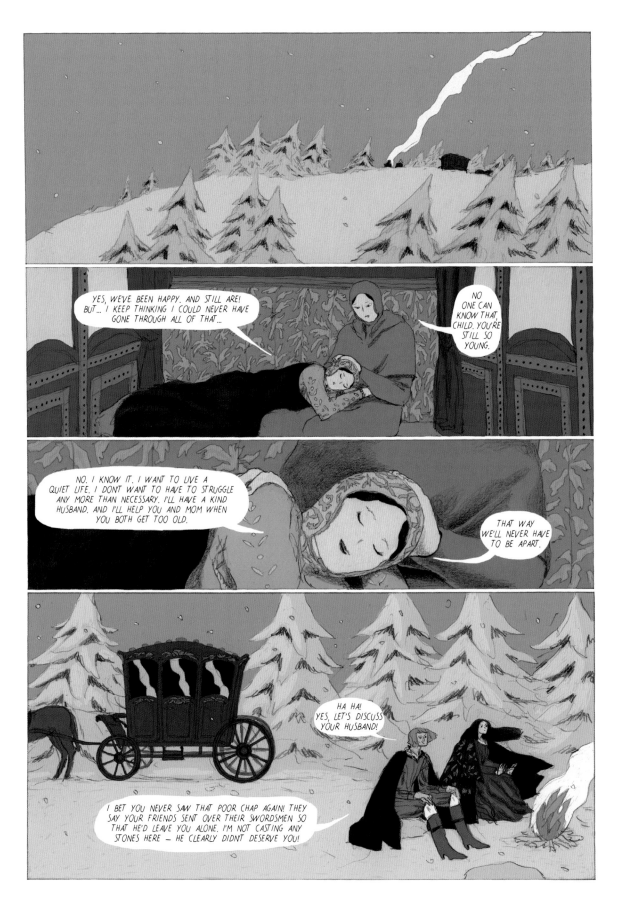

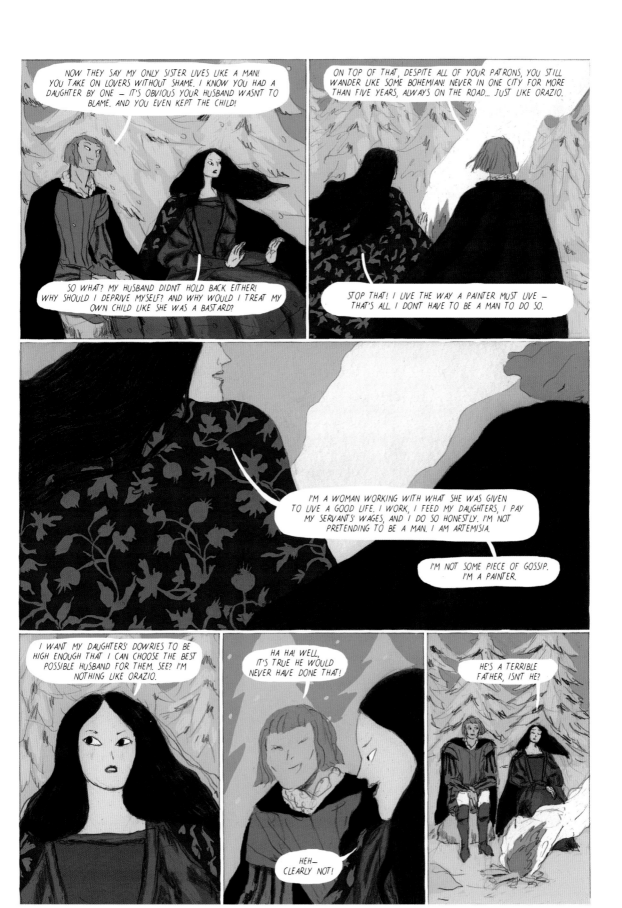

HE **IS** A TERRIBLE FATHER, ARTEMISIA. BUT YOU ARE A GOOD DAUGHTER. GO TO HIM.

HE'S AWFULLY LONELY IN LONDON, AND THE ENGLISH GIVE HIM A HARD TIME.

COME NOW! IS HE REALLY SO OLD THAT HE NEEDS SOME WOMAN TO FEED HIM AND WIPE HIS MOUTH?

DON'T BE STUPID! HE NEEDS A PAINTER — HIS EQUAL. AND THE ONLY LIVING PERSON HE DEEMS WORTHY ENOUGH IS YOU.

EVERY DAY HE TELLS FRANCESCO AND I HOW WE'RE NOT UP TO IT!

IT SEEMS LIKE A LIFETIME AGO THAT YOU LEFT, AND EVER SINCE THEN, HE SPEAKS OF YOU AS IF YOU'RE STILL THERE, AND ACTS AS THOUGH HIS SONS NEVER EXISTED. I'M STARTING TO THINK THAT IN HIS MIND, YOU TWO ARE ONE AND THE SAME. FOR HIM TO SPEND THE REST OF WHAT LITTLE REMAINING LIFE HE HAS WITHOUT SEEING YOU IS CRUEL — FOR BOTH OF YOU! GO SEE HIM.

NO. I MUST GO TO NAPLES, AND THEN ROME AND VENICE NEXT YEAR. I HAVE BETTER THINGS TO DO!

DON'T WORRY, UNCLE — SHE'LL COME TO LONDON. IT WON'T BE SIX MONTHS BEFORE SHE SETS FOOT ON YOUR RAINY ISLAND.

NONSENSE, CHILD — WHAT ARE YOU TALKING ABOUT?

YOU KNOW MY MOTHER ONLY DOES AS SHE PLEASES. AND JOINING ALL OF YOU OVER THERE IS EXACTLY WHAT SHE YEARNS FOR!

POOR, STUBBORN MOMMA! YOU'VE BEEN THINKING ABOUT GOING TO SEE HIM AND SHOW HIM YOUR WORK FOR SO LONG NOW! WHAT ARE YOU WAITING FOR? FOR HIM TO BEG?

MY POOR PRUDENZIA! HOW LITTLE YOU KNOW ME AFTER ALL THESE YEARS!

I LISTENED TO HER STUBBORN ASSERTIONS THAT SHE'D NEVER GO TO LONDON, ALL THE WHILE KNOWING THAT IN FACT, IT WAS THE ONLY THING SHE HAD IN MIND. SHE WAS ALREADY CONSIDERING WHICH PAINTINGS TO BRING WITH HER, DELIBERATING WHICH ONES WERE DESERVING OF HER GREATEST CRITIC'S JUDGMENT — THE ONES THAT SHOWED HOW SHE'D SURPASSED HIM, AND THE ONES HE'D MOST CERTAINLY ALREADY HEARD OF...

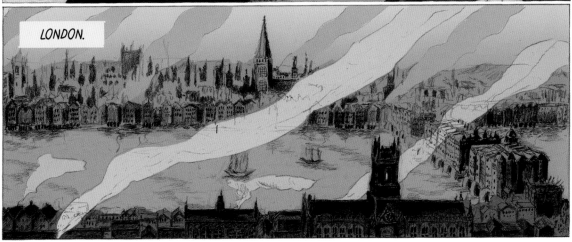

LONDON.

ARTEMISIA!

HA HA! MARCO! FRANCESCO! WHAT IS THIS AWFUL COUNTRY YOU'VE HOLED YOURSELVES UP IN?

WE'VE BEEN AWAITING YOUR ARRIVAL FOR THREE DAYS!

AFTER ALL THESE YEARS!

LOOKS LIKE FATHER COULDN'T BOTHER TO COME GREET ME.

HE DASHED BACK TO HIS CANVAS AS SOON AS HE SAW YOUR CARRIAGE PULL INTO THE DRIVE. HE WOULDN'T WANT TO BE CAUGHT WAITING!

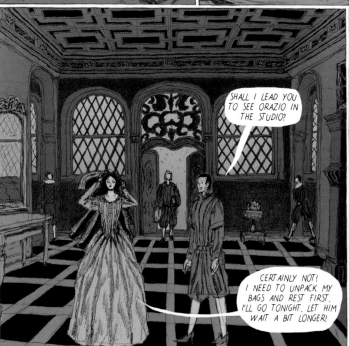

SHALL I LEAD YOU TO SEE ORAZIO IN THE STUDIO?

CERTAINLY NOT! I NEED TO UNPACK MY BAGS AND REST FIRST. I'LL GO TONIGHT. LET HIM WAIT A BIT LONGER!

PFFF...

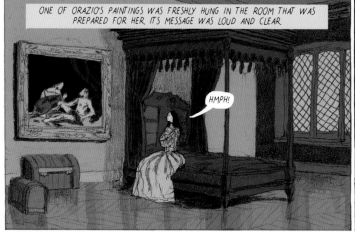

ONE OF ORAZIO'S PAINTINGS WAS FRESHLY HUNG IN THE ROOM THAT WAS PREPARED FOR HER. ITS MESSAGE WAS LOUD AND CLEAR.

HMPH!

WELL, WELL, OLD ORAZIO... LOOKS LIKE YOUR PAINTING IS STILL QUITE STRONG!

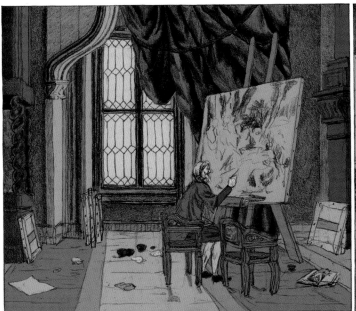

HELLO, ORAZIO!

MY DAUGHTER! WHAT A SURPRISE!

AND I WHO THOUGHT A WOMAN OF YOUR AGE AND STANDING WOULD NEED TO REST ON A FEATHER BED FOR AT LEAST A DAY AFTER SUCH A VOYAGE!

HA HA! HOW I'VE MISSED YOUR TENDERNESS ALL THESE YEARS, DEAREST FATHER!

DID YOUR DAUGHTERS ACCOMPANY YOU? DO THEY ALSO PAINT?

OH, NO! THEY STAYED IN FLORENCE, AND BY THE GRACE OF GOD, THEY ONLY PAINT FOR THE FUN OF IT!

SO THEY DIDN'T INHERIT YOUR TALENT?

WELL, THEY NEVER HAD A TEACHER AS GOOD AS I DID. BUT HONESTLY, I'M RELIEVED. IN THE END, I ONLY WANT THEM TO LEAD EASY, HAPPY LIVES!

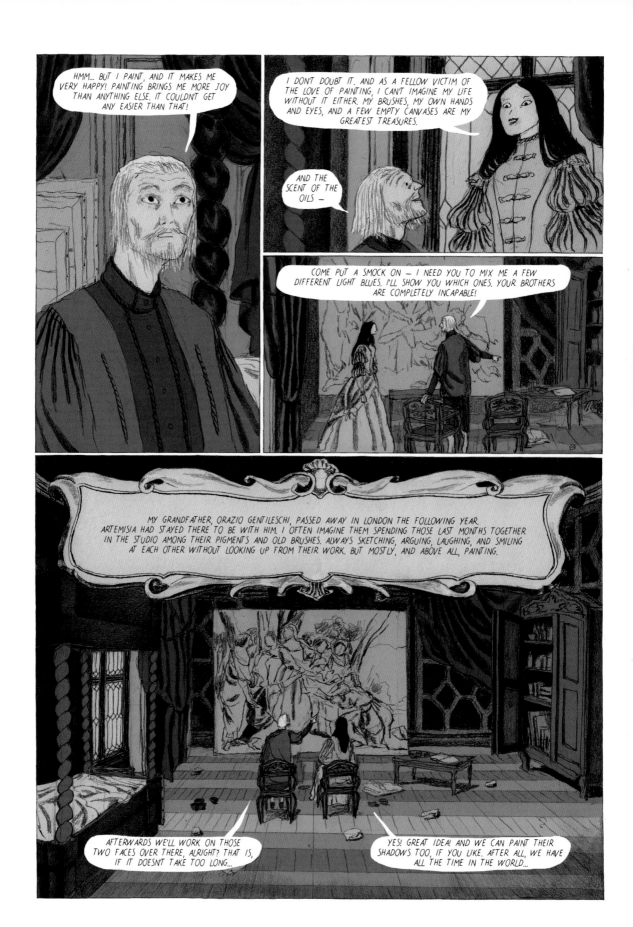

ARTEMISIA GENTILESCHI (1593-1652)

This is a fictionalized graphic retelling of the story of Artemisia Gentileschi. While it is based on the historical record, some details have been changed. The biographical information is mainly drawn from work by Alexandra Lapierre.

Artemisia Gentileschi grew up in a Rome where Caravaggio's stark, dramatic, realist style reigned. Though Caravaggio died before reaching the age of forty, his intense chiaroscuro portraits and strikingly sparse décor brought him enormous success throughout all of 17th century Europe, and impacted virtually every artist that succeeded him. The Baroque period swept across the continent.

Artemisia's father, Orazio Gentileschi (1563-1639), was among the more talented and successful of Caravaggio's followers. Born in Pisa, Orazio came to Rome in his youth to begin a career as a painter, where he proved himself to be reasonably successful. A series of ruling Roman popes prided themselves as patrons of the arts, and encouraged other aristocratic art lovers to invest as well. As a result, lucrative commissions abounded, and many artists were able to do quite well for themselves. Orazio, a widower single-handedly raising four children, could more than afford to feed his family — he could also teach them his craft. It was Artemisia, his only daughter, who proved to be the true talent.

Despite significant and nearly insurmountable societal constraints, women painters did exist. One prominent example was one of Artemisia's near-contemporaries, Sofonisba Anguissola (1532-1625), who split her time between Sicily and the Spanish noble court, where she painted hundreds of royal portraits — yet she was discouraged from signing her own work.

Unrecognized as artists and barred from studying the nude figure, women with the courage to brave these restrictions were limited to portraits and still lifes, rather than the historical and allegorical paintings that were most sought after and respected. Despite this oppressive climate, Artemisia not only persevered but thrived, ultimately becoming the first woman to be accepted into the Accademia delle Arti del Disegno in Florence. This was a historical turning point: Artemisia was among the first women in history to be recognized with the same legal rights and status as male artists.

It was also a personal victory for Artemisia. The academy's recognition elevated her and her work on its own merits, and not as mere novelties or collector's items painted by a woman whose sexual assault and ensuing trial had become the gossip of the art world.

Her acceptance into the academy also afforded her the independence and financial freedom needed to travel and take commissions as her father did, in Rome, Florence, Venice, and London, as well as Naples, where she would spend her autumn years. Not as much is known about her later years apart from some wonderful correspondence, but she continued to receive high-profile commissions up until her death in the 1650s.

Artemisia's assailant, Agostino Tassi (1578-1644), has often been cast as a troubled genius who led a tumultuous life of crimes, arrests, and abuse of young women. In truth, friends in high places and a vehement self-defense kept him free from serious prison time. Even after being found guilty of raping Artemisia in a highly publicized trial, his sentence went unenforced and later annulled. Much of Tassi's

work has survived; mainly frescoes and paintings of landscapes and architectural trompe-l'œils.

Like his daughter, Orazio Gentileschi was also able to move past the scandal of the trial and resume his career. He lived nomadically in each of the major Italian cities, taking commissions from patrons until his death in London at 85 years old. He left behind a sizable artistic œuvre.

Artemisia died less than fifteen years after her father. In the centuries that followed, her paintings were often erroneously attributed to him, and it wasn't until well into the 20th century that critics and art historians took an interest in her and her personal story. The trial transcripts had been preserved and were rediscovered in the new-found interest in the artist and her work. Reading them, you can hear Artemisia testifying in her own words, recounting her rape in such horrific detail that even today, centuries after its transcription, her voice burns off the page with white-hot anger.

Her paintings were also finally brought to light once more — passionate, forceful, elegantly rendered biblical and mythological scenes that centered and humanized women in their complexity, joy, and rage. Susanna accosted and falsely accused by voyeurs; Holofernes coolly and brutally decapitated by Judith. While she was far from the first to paint these subjects, her renditions come alive with feeling. Rather than simple parables, Artemisia was painting dramatic theatrical scenes in which she often staged herself in the role of the heroine and occasionally added Tassi's physical traits to the throat-slit general or the lecherous voyeur.

Unfortunately, this led early art historians to conclude that Artemisia was merely a victim who spent her whole life painting bloody, violent scenes to exorcize her trauma. If one were to take this perverse logic even further, one may as well say we should thank Tassi for involuntarily bringing us this bright-shining star of the Baroque. Why is it so hard for us to imagine that the profound emotional force and immediacy of Artemisia's paintings came from her own fighting spirit, as the sum of all her lived experiences, rather than springing from one foundational trauma?

Downplaying Artemisia's strength and drive also downplays the challenges facing women in the Renaissance: rampant misogyny, few civil rights, and contradictory demands to be at once pious, submissive, virginal, modest, attractive, fertile, and, above all, inferior. Any husband, brother, or father, no matter how kind, cruel, young, or foolish, was always held in higher esteem than the women in his charge. Talent and genius like Artemisia's was ignored and dismissed. Why do we assume her anger was only reserved for Tassi? Rather than slitting his throat through her paintings, she may have been going for the jugular of a society that either granted every right or no rights at all, solely on the basis of sex, and allowed abusers to bribe their way through trials and suffer no consequences.

To be truly fair to Artemisia, however, why not evaluate her works more on their merit and craft, and less on the gender of the artist? After all, these are incredibly striking, unique, and passionate works that still have powerful stories to tell and feelings to communicate — even four centuries later.

BIBLIOGRAPHY

Garrard, Mary D. *Artemisia Gentileschi: The Image of the Female Hero in Italian Baroque Art.* Princeton: Princeton University Press, 1988.

Garrard, Mary D. *Artemisia Gentileschi Around 1622: The Shaping and Reshaping of an Artistic Identity.* Oakland: University of California Press, 2001.

Lapierre, Alexandra. *Artemisia: Un duel pour l'immortalité.* Paris: R. Laffont, 1998.

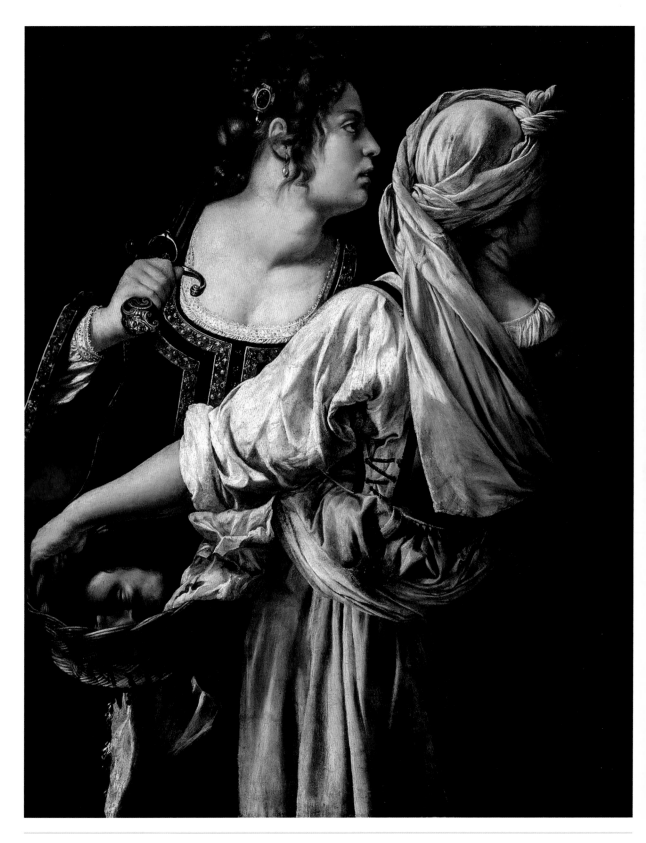

Judith and her Maidservant, 1613–14, Palazzo Pitti, Florence.

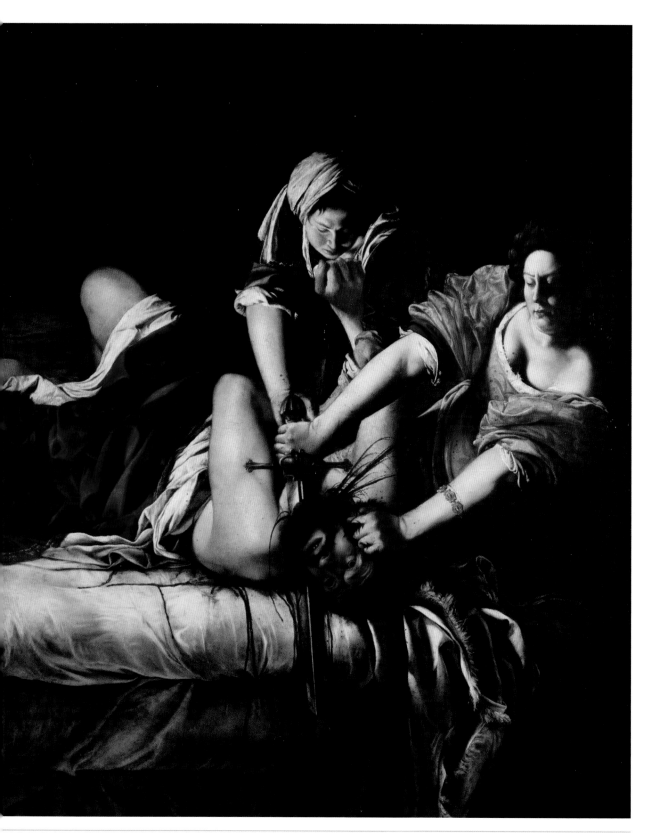

Judith Slaying Holofernes, 1614–1620, Galleria degli Uffizi, Florence.

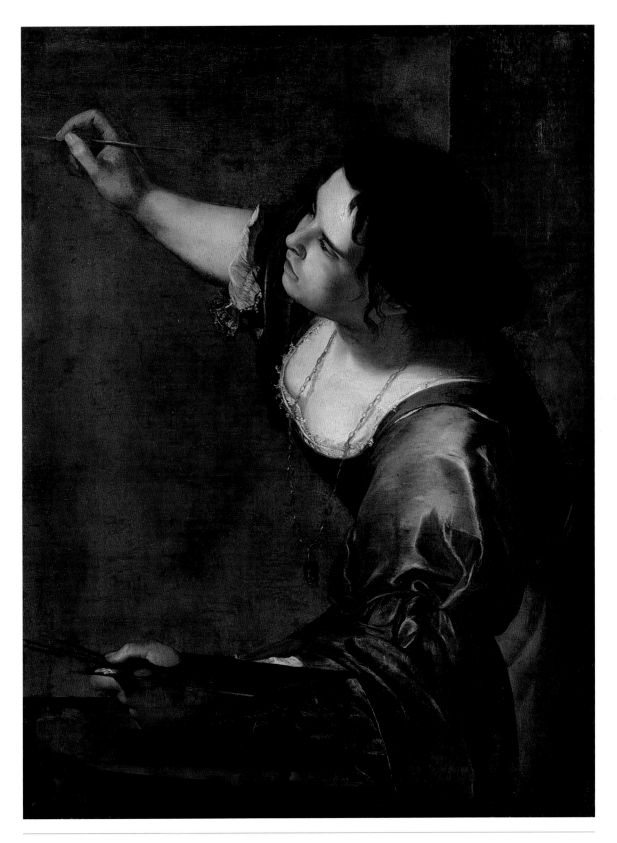

Artemisia Gentileschi, *Self-Portrait as the Allegory of Painting*, 1638–39, Royal Collection.

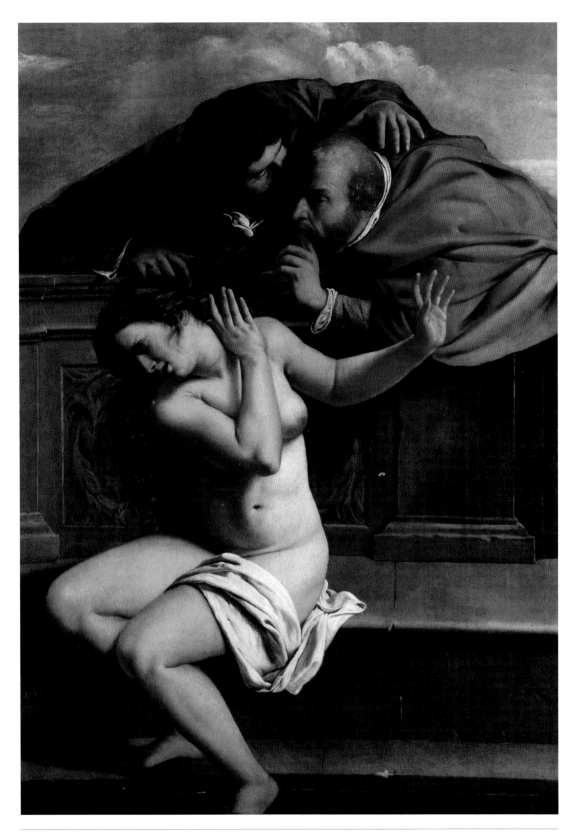

Susanna and the Elders, 1610, Schönborn Collection, Pommersfelden.